ABOUT FACE

ABOUT
FACE

SAGE SOHIER

with an essay by
Carolyn Abbate

Columbia | PRESS
COLLEGE CHICAGO

Published in 2012. First Edition.
Printed in Singapore on acid-free paper.

Columbia College Chicago Press
600 South Michigan Avenue
Chicago, Illinois 60605-1996, U.S.A.

Distributed by the University of Chicago Press
www.press.uchicago.edu

20 19 18 17 16 15 14 13 12 1 2 3 4 5

ISBN: 978-1-935195-36-8

All royalties from the sale of this book will be contributed to the HUGS (Help Us Give Smiles) Foundation.

For Mack, who introduced me to the mysteries of facial surgery . . . always
with compassion, and always, too, with his special brand of warm humor.

CONTENTS

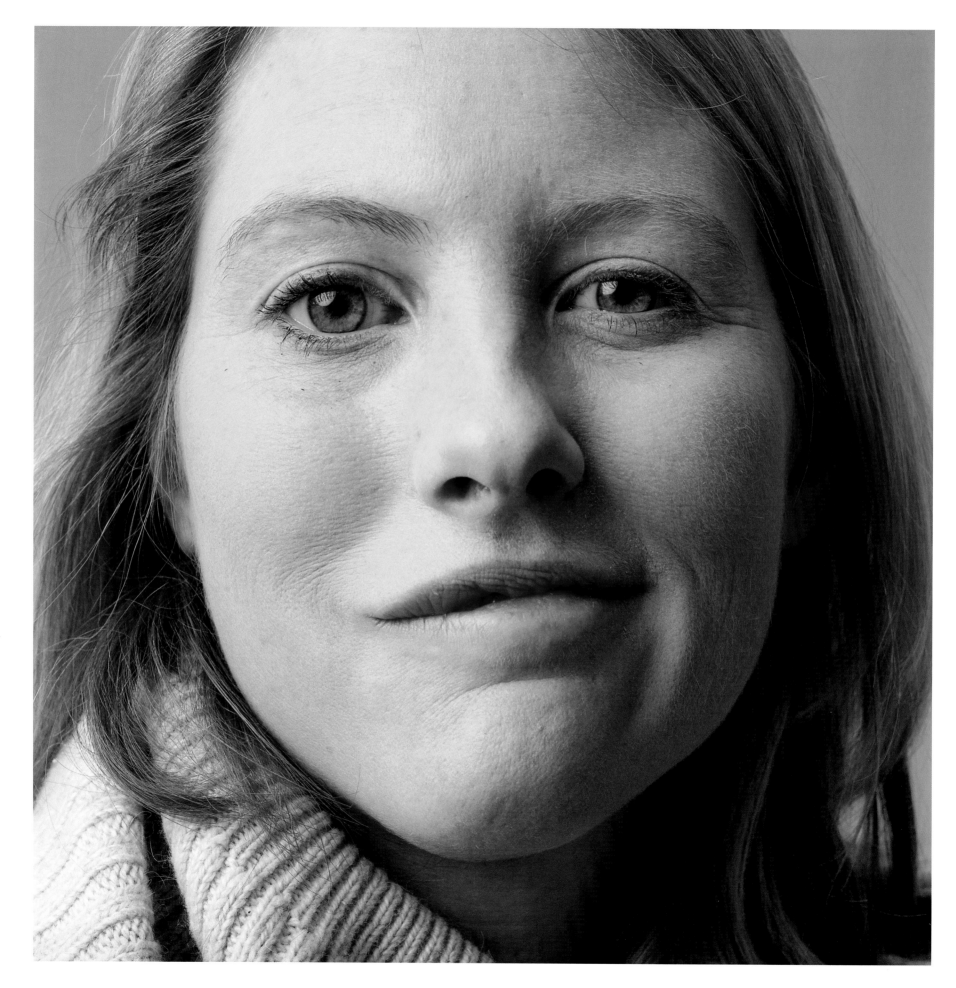

FACIAL PARALYSIS AND THE ORIGINS OF ABOUT FACE

Many of us find fault with our faces: vanity, aging and insecurities all take their toll on our self-image, and few of us achieve our notions of perfection; but, we have the luxury of taking for granted our ability to show emotion through control of our facial expressions.

For the past three years I have been spending time at the facial nerve clinic of Drs. Tessa Hadlock and Mack Cheney in Boston, photographing people who have varying degrees of facial paralysis, a condition that usually occurs on just one side of the face. The causes are many, including Bell's palsy, tumors, strokes, accidents, and congenital nerve damage. At the clinic, patients are offered long-term physical therapy, often coupled with Botox therapy. (Botox is used for medical as well as cosmetic reasons. It can be injected into areas of the face that are overactive, and can also be used to weaken the normal side of the face in someone with facial paralysis, providing more symmetry to the two sides). In more recalcitrant cases, surgery is an option. Most of the portraits in this series were made during a patient's first or second visit to the clinic, before the beginning of treatment. In some cases, I have followed a person's progress over time, and have been privileged to witness hope and excitement emerge as the patient regains the ability to smile, speak, and eat more normally.

The origins of this project extend back into the 1990's, when I photographed patients of Drs. Cheney

and Hadlock before, during, and after "free flap" reconstructive surgery. Most of their patients at that time had serious facial cancers, and required heroic measures to restore both function and form after the malignancies were removed. The photos I made then in black and white were compelling to some viewers but too graphic and disturbing for others. I endeavored to humanize these sequences of photographs by showing patients with their families following the surgical experience, but the pictures were still very difficult to look at. Though intrigued by this body of work, I realized that I had never fully figured out how to make it succeed—how to make portraits of people with whom viewers could identify and feel deeply connected.

In 2007, Tessa and Mack contacted me about a different group of patients with facial paralysis, and invited me to make portraits of them. I was ambivalent. My husband David had died the year before, after a long struggle with leukemia, and it was hard to envision spending more time in a hospital with people in distress. David's illness was one of the reasons I had first become interested in photographing facial surgery: it seemed like a more visually explicit equivalent of what he was experiencing medically. And, although these patients faced very difficult surgeries and even temporary disfigurement, in most cases they improved—they survived. So, what many observers found disturbing, I found strangely hopeful.

Not wanting to turn Mack and Tessa down, I decided to return to the hospital for a few weeks in January 2008; perhaps I could at least help them by making some portraits for their practice. It was a challenge to meet and talk to this new group of patients who were so profoundly distressed by how they looked, and who were often in great discomfort as well. I worried that I was merely adding to their troubles by photographing them. But I was gripped by their poignant stories and moved by their sense of hope. Moreover, the faces that appeared in these photographs were striking, even beautiful. Once again, I became deeply involved on a personal level and committed to continuing the project. Initially, I photographed both in black and white and color, and again followed some of the patients into the operating room to photograph their surgeries. When I stepped back to review what I had done, after the first few months of work, it was clear that the color portraits were more compelling than anything else. I became especially interested in the pictures that included family with the patient, and how much emotion was conveyed. I felt that perhaps I had finally figured out how to photograph people rising above tremendously difficult circumstances and how to make pictures that showed individual strength and composure in the face of suffering.

Upon meeting new patients, I carefully explain the intention of my project and invite them to pose for me; then I ask them to tell me their story. I listen and watch closely as they speak. What they tell me about their experience informs the pictures I take later, and often leads to a strong rapport between photographer and subject. It seems that what I can offer, in exchange for my subjects' generosity in sitting for me, is to listen, to be an interested and concerned person with whom they can share their experience and feelings. Most people I photograph are acutely aware of their imperfections

and try to minimize them. Some have confided in me that, in their attempt to look more normal, they strive for impassivity and repress their smiles. They worry that this effort is altering who they are emotionally and affecting how other people respond to them. While most of us assume that our expressions convey our emotions, it seems that the inverse can also be true: our emotions can, in some ways, be influenced by our facial expressions.

My intention has been to make portraits that are psychologically powerful, visually intriguing, and that challenge conventional notions of portraiture. When looking at someone with partial facial paralysis, we are in a sense seeing two versions of the same face at once, with each side conveying different emotions. Like gazing at a cubist painting, we observe multiple facets of someone in a single instant. As a visual artist, I find myself fascinated by the intensity of glimpsing two expressions simultaneously, a literal "two-facedness" that mesmerizes by its terrible beauty. At the same time, I hope these pictures bear witness to the incredible courage required to deal with medical afflictions, especially when they affect one's primary appearance. Even minor facial problems challenge and potentially diminish a person's sense of self; the poise and inner strength that it takes to deal with this, while at the same time presenting oneself to the world, is remarkable. As I've listened to and photographed these people, I've been struck by how much complex feeling is revealed in their faces and gestures. Their brave self-presentation to the camera, at a time when they are most vulnerable and camera-shy, elicits something wistful, tender, and deeply human.

ABOUT
FACE

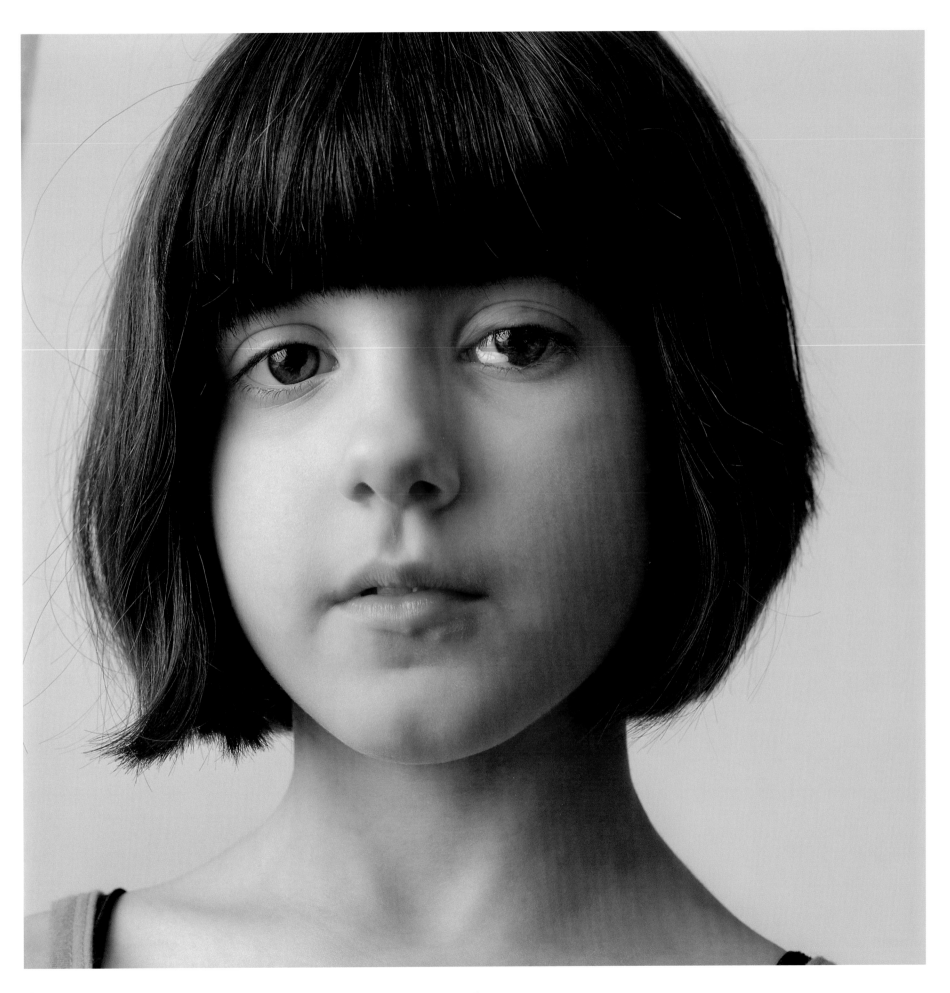

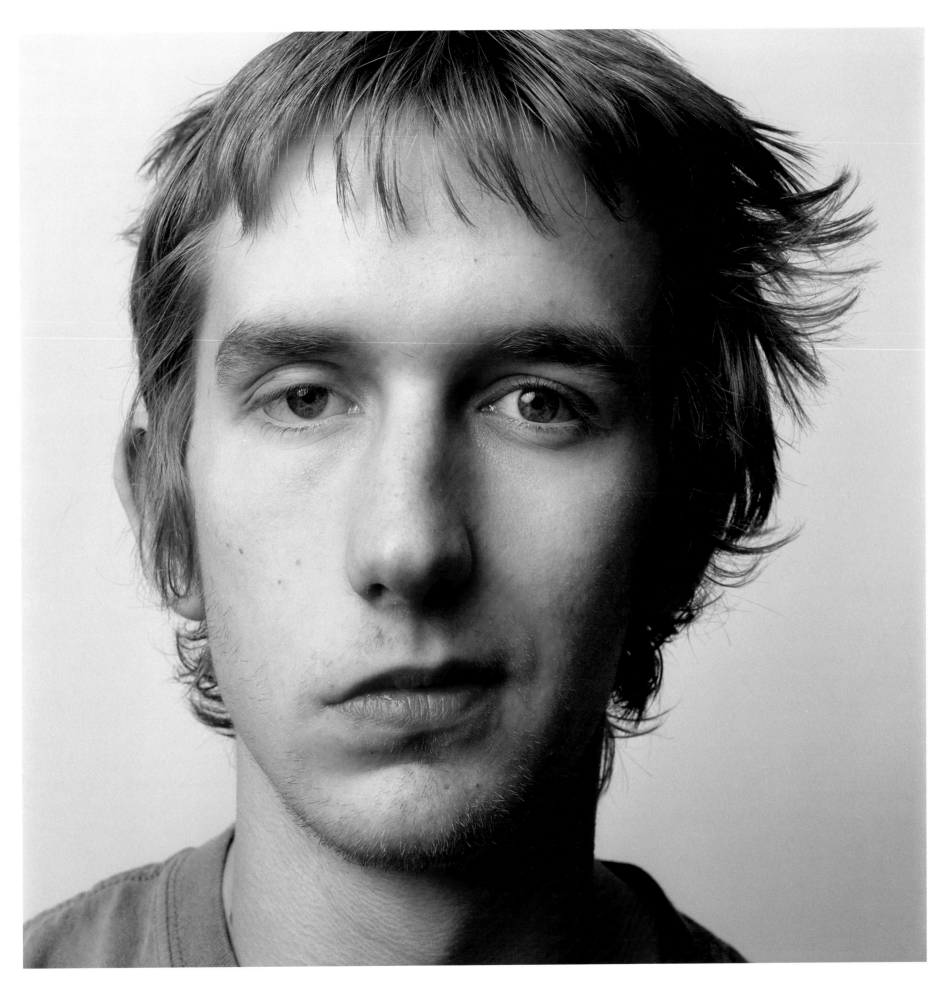

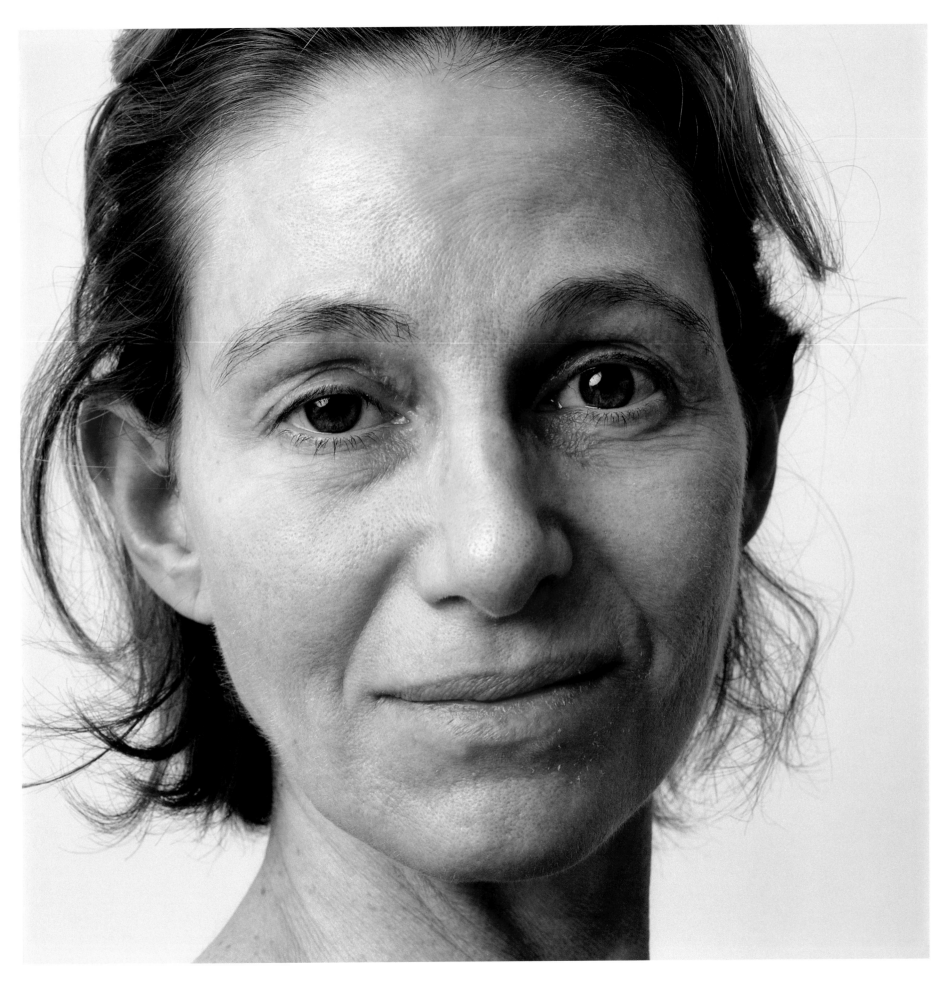

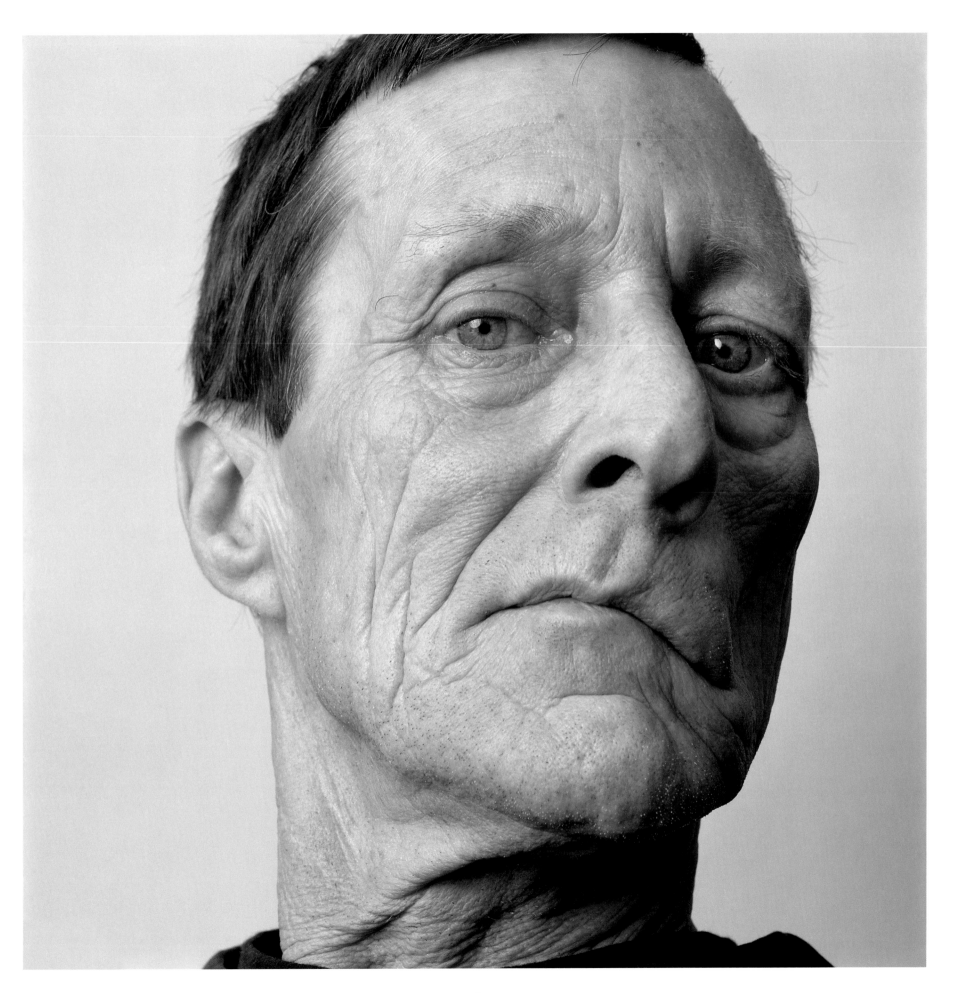

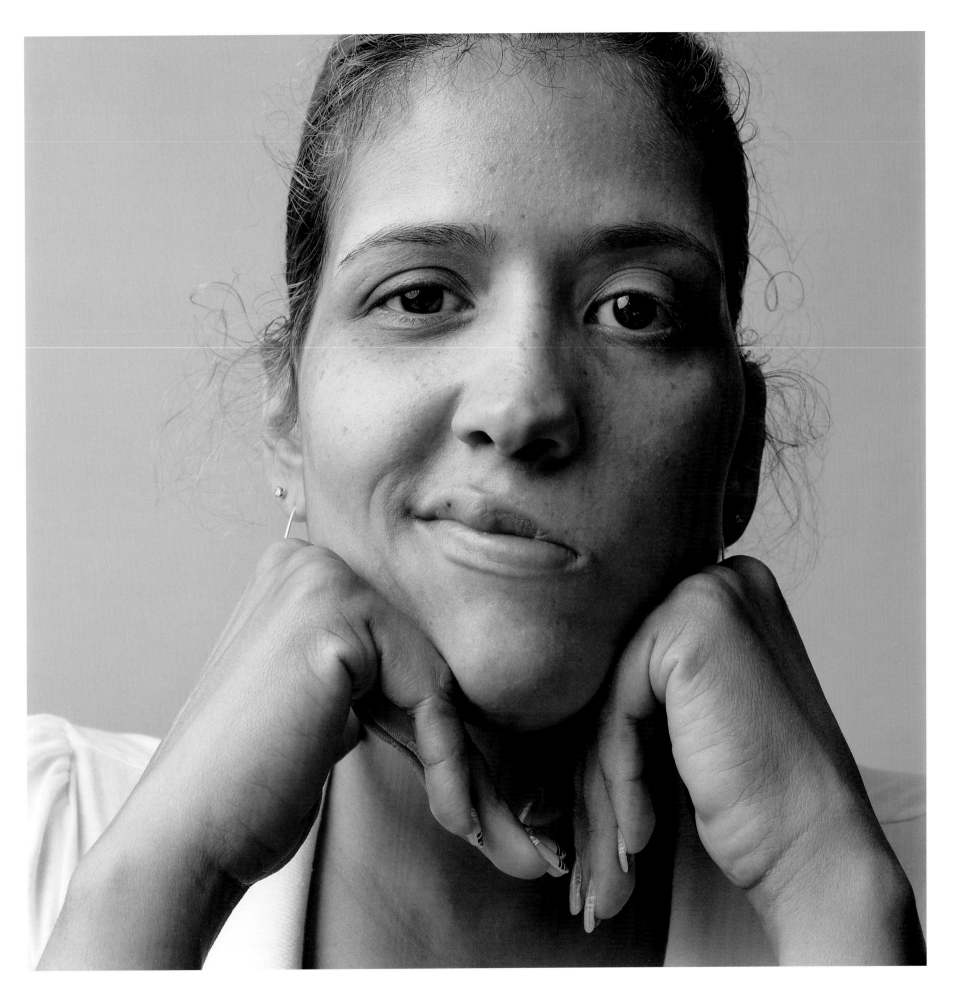

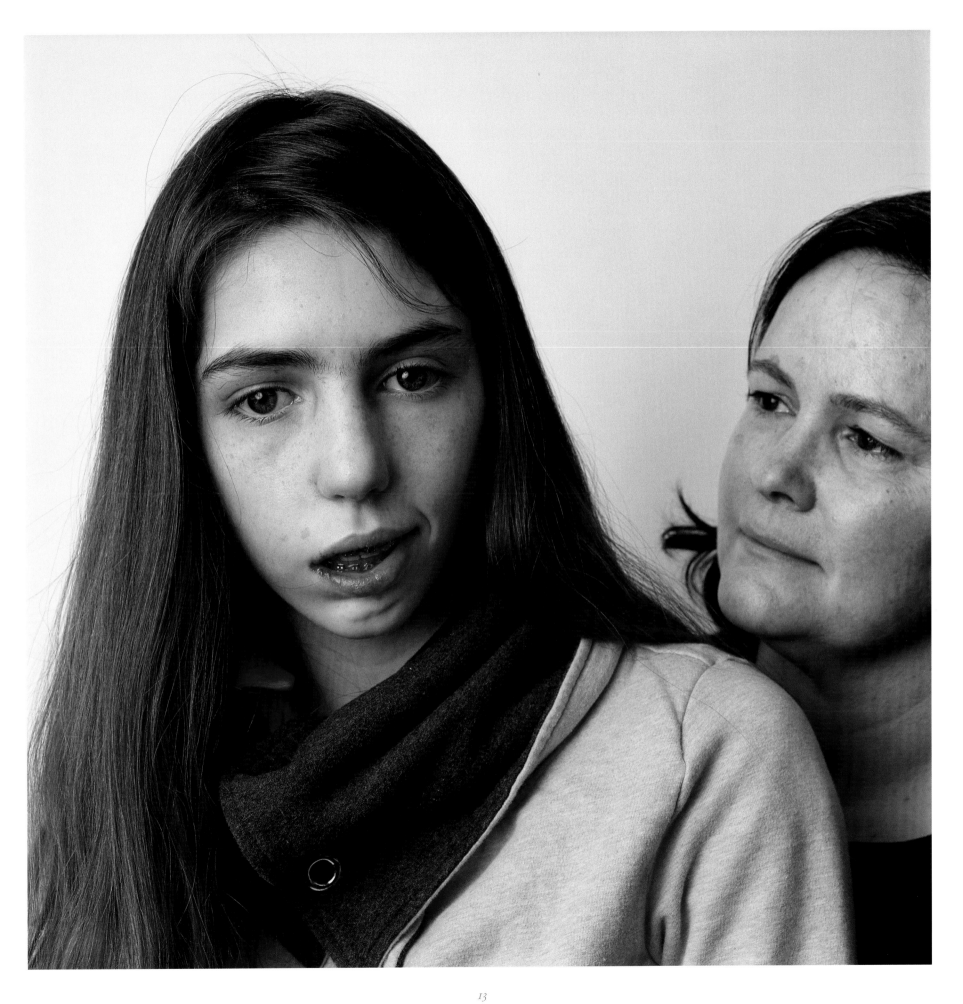

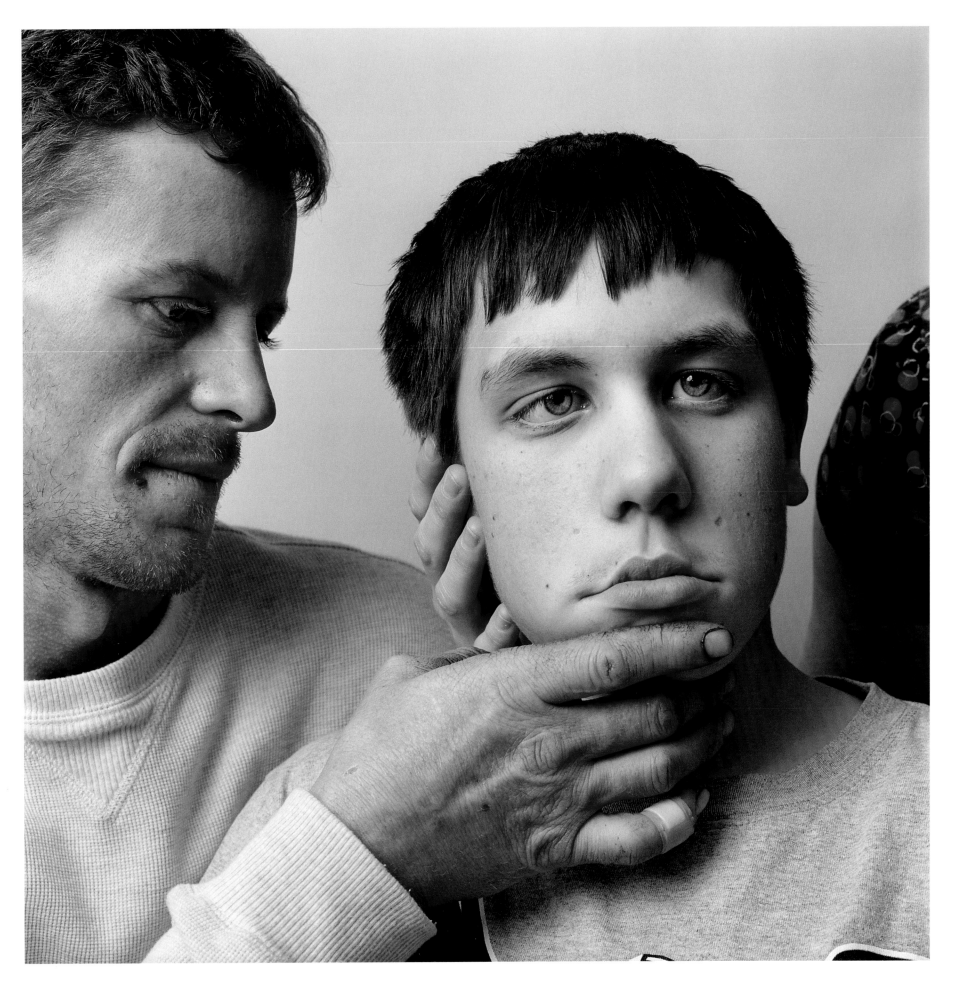

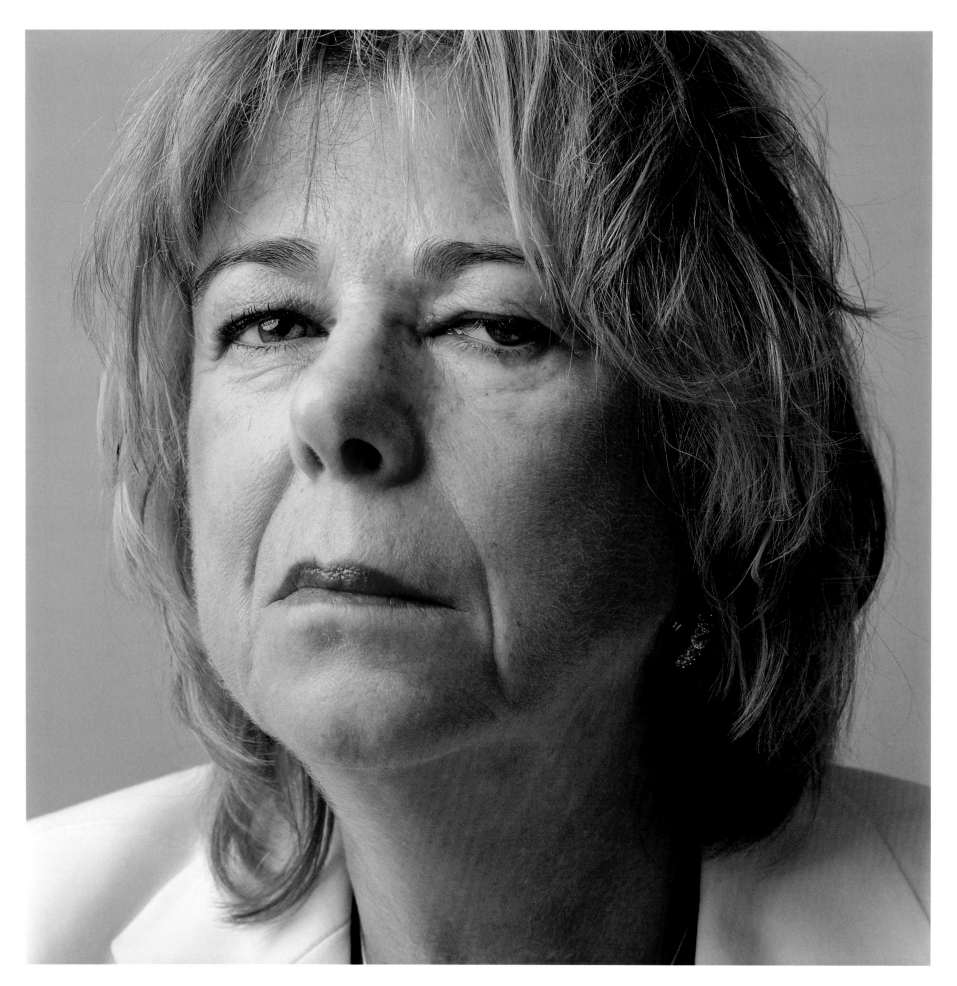

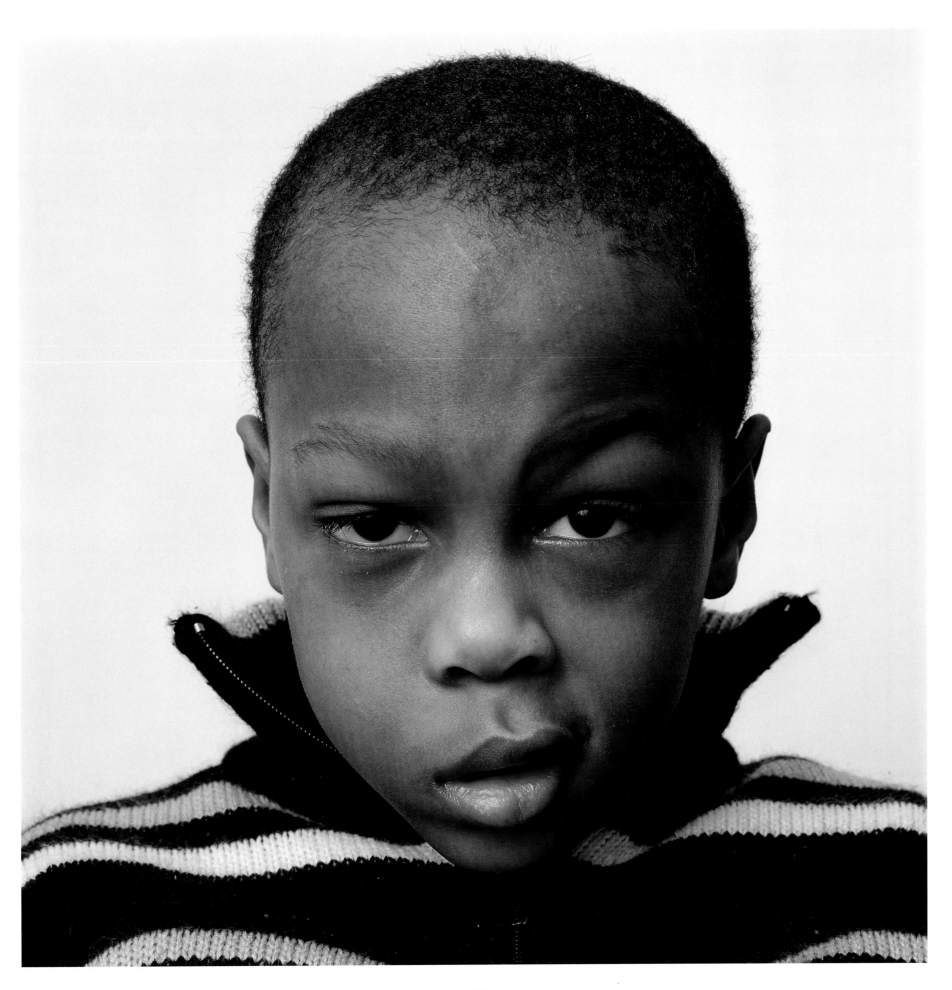

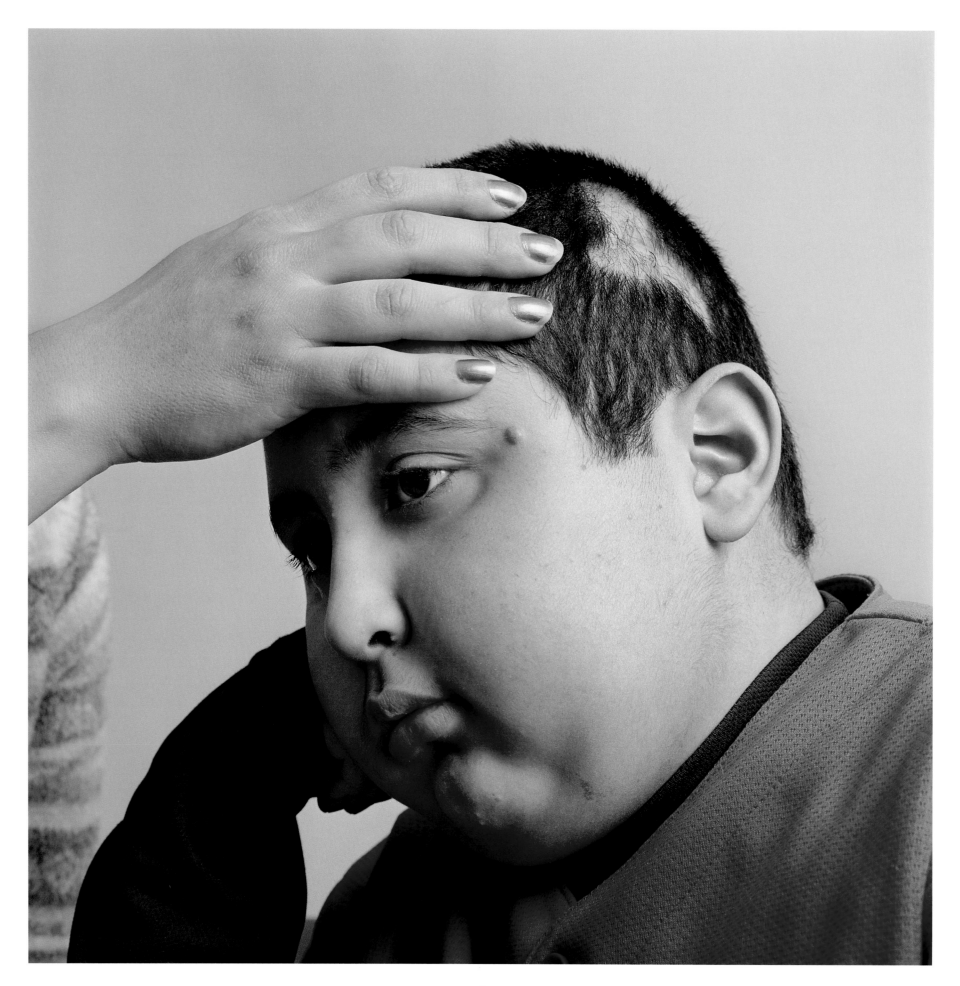

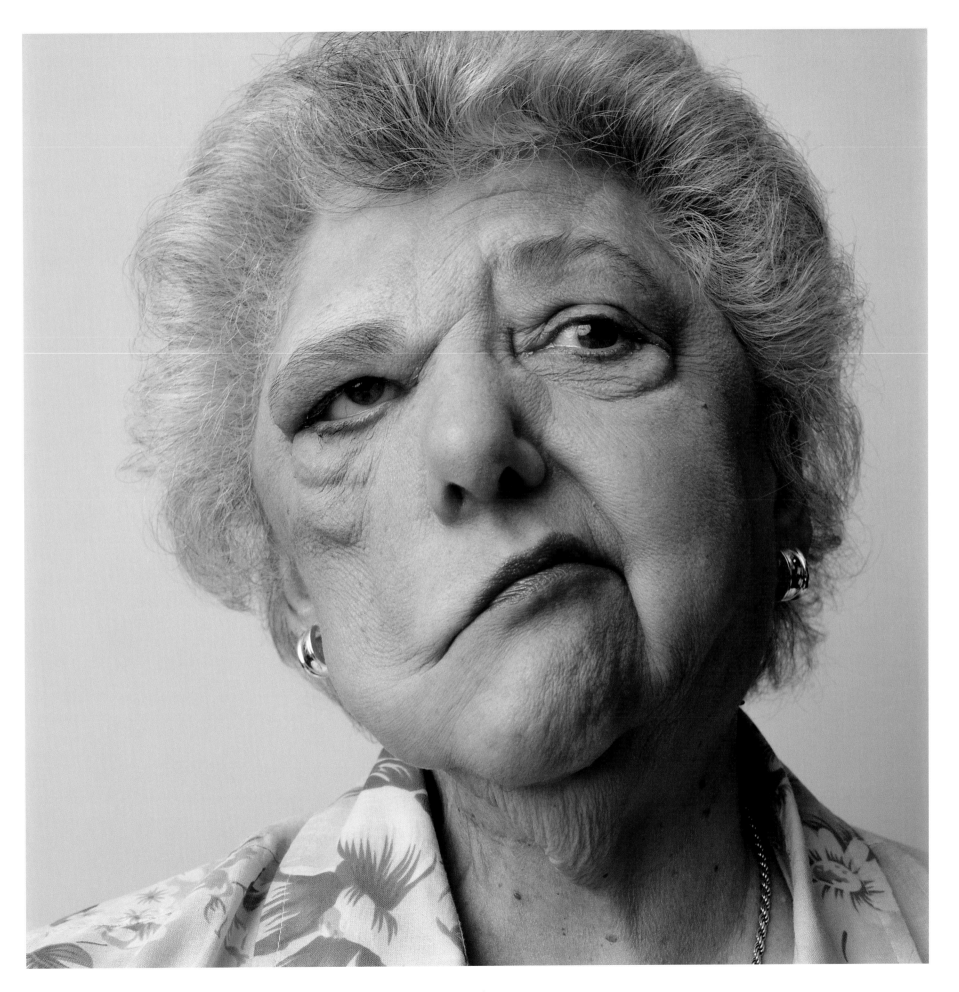

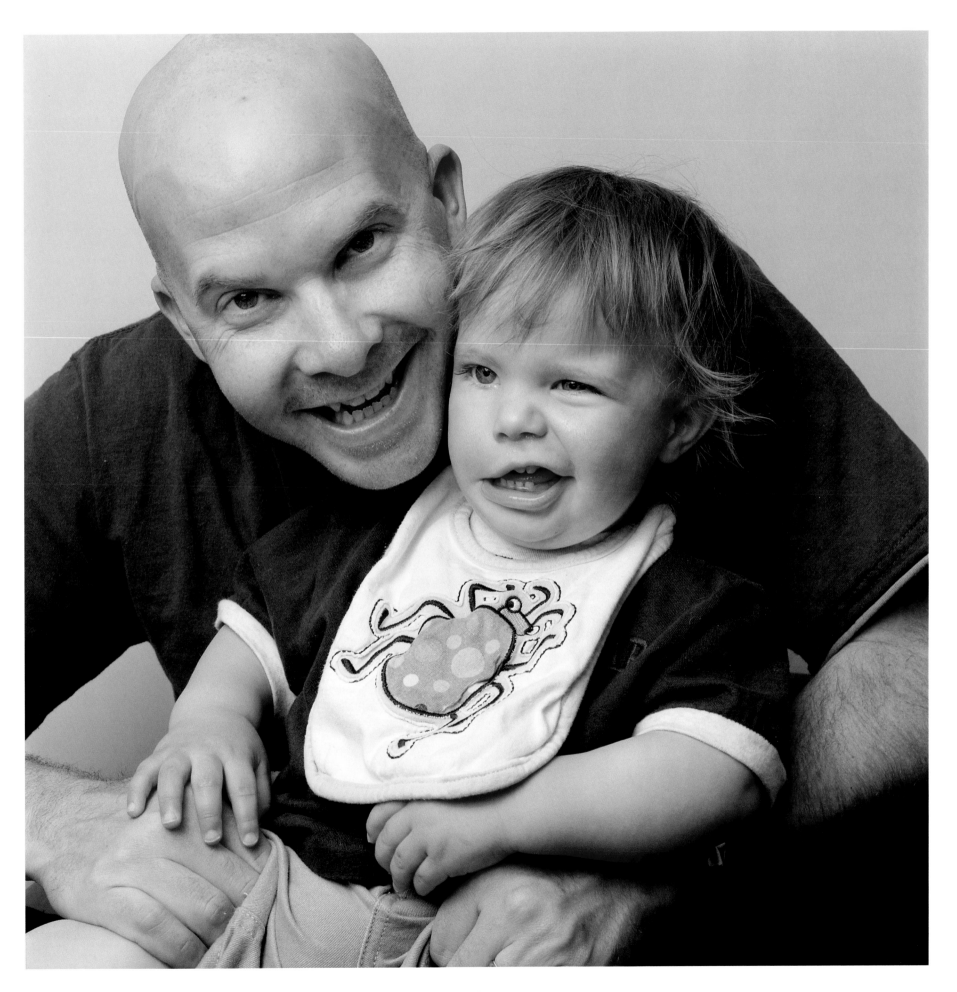

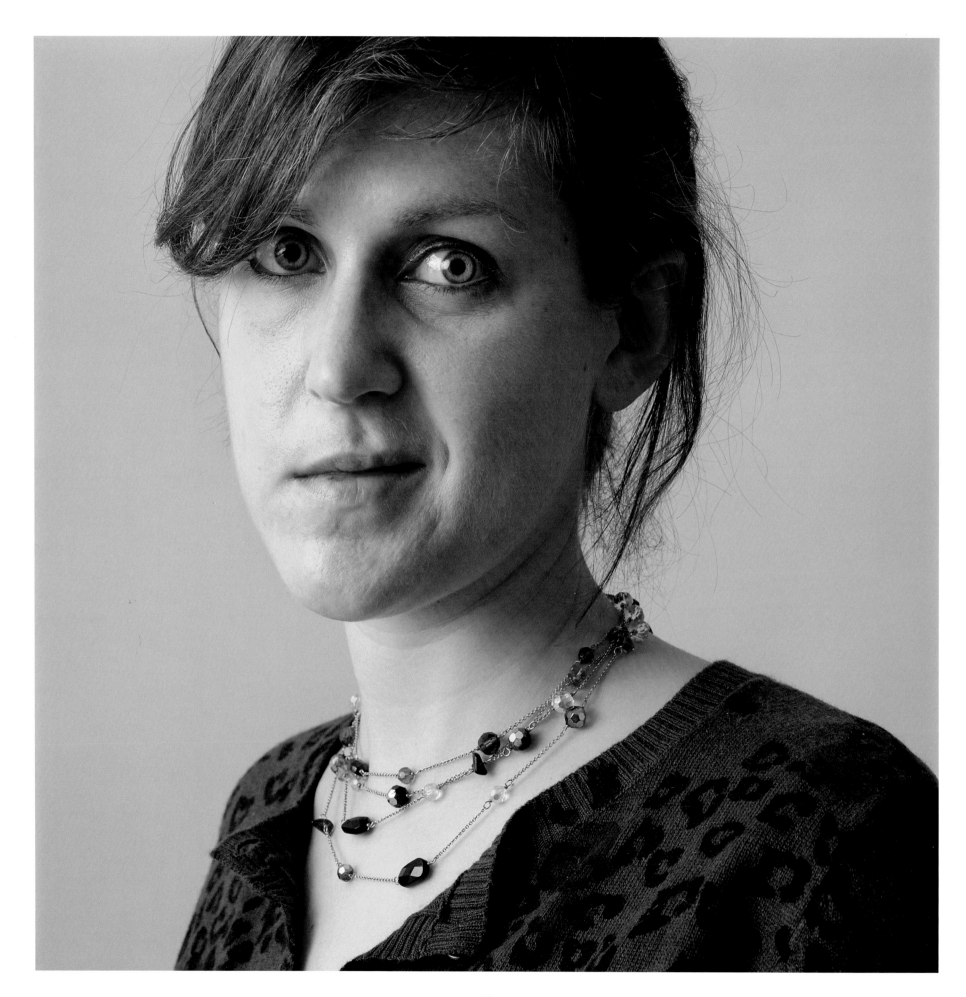

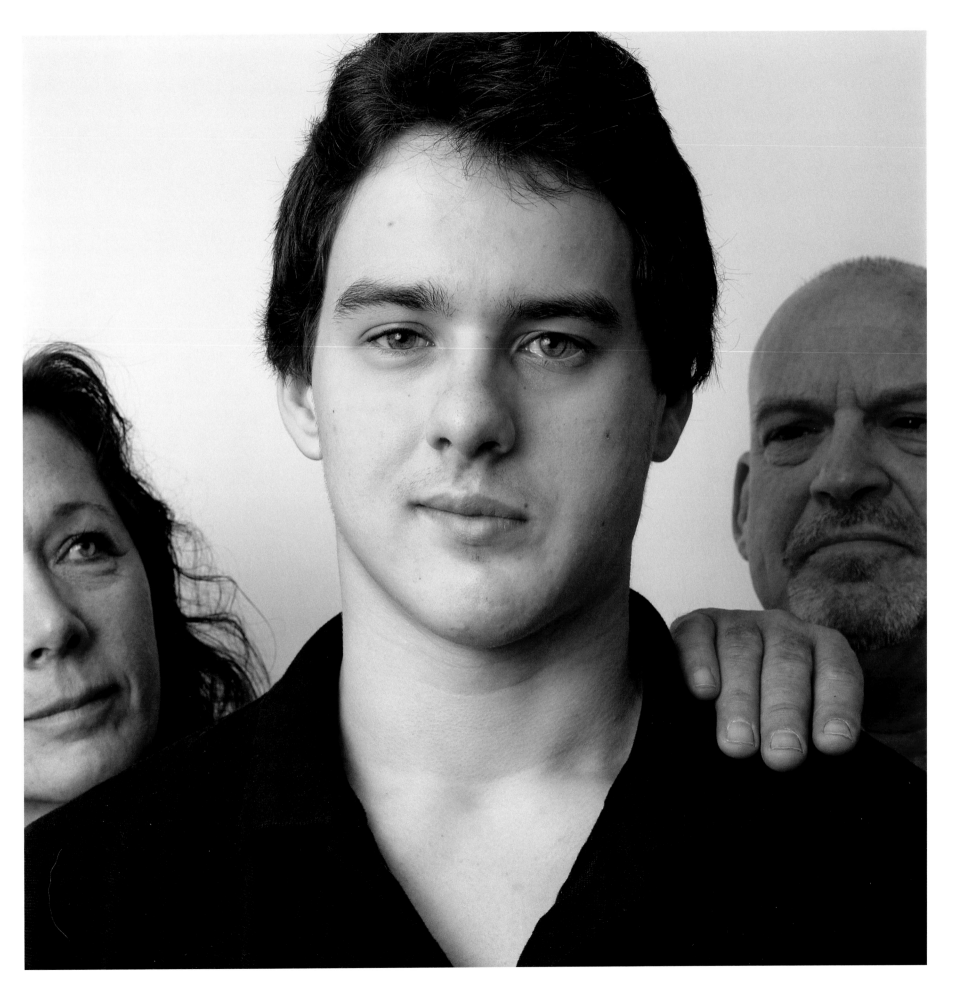

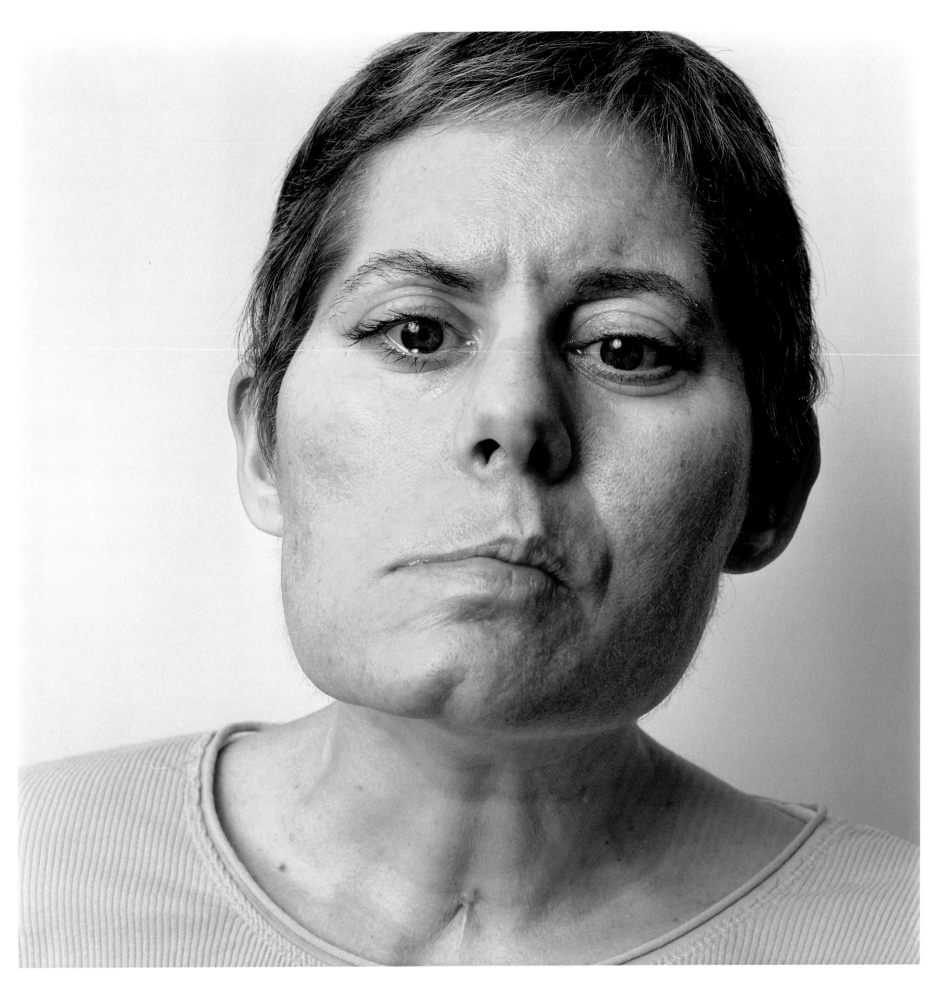

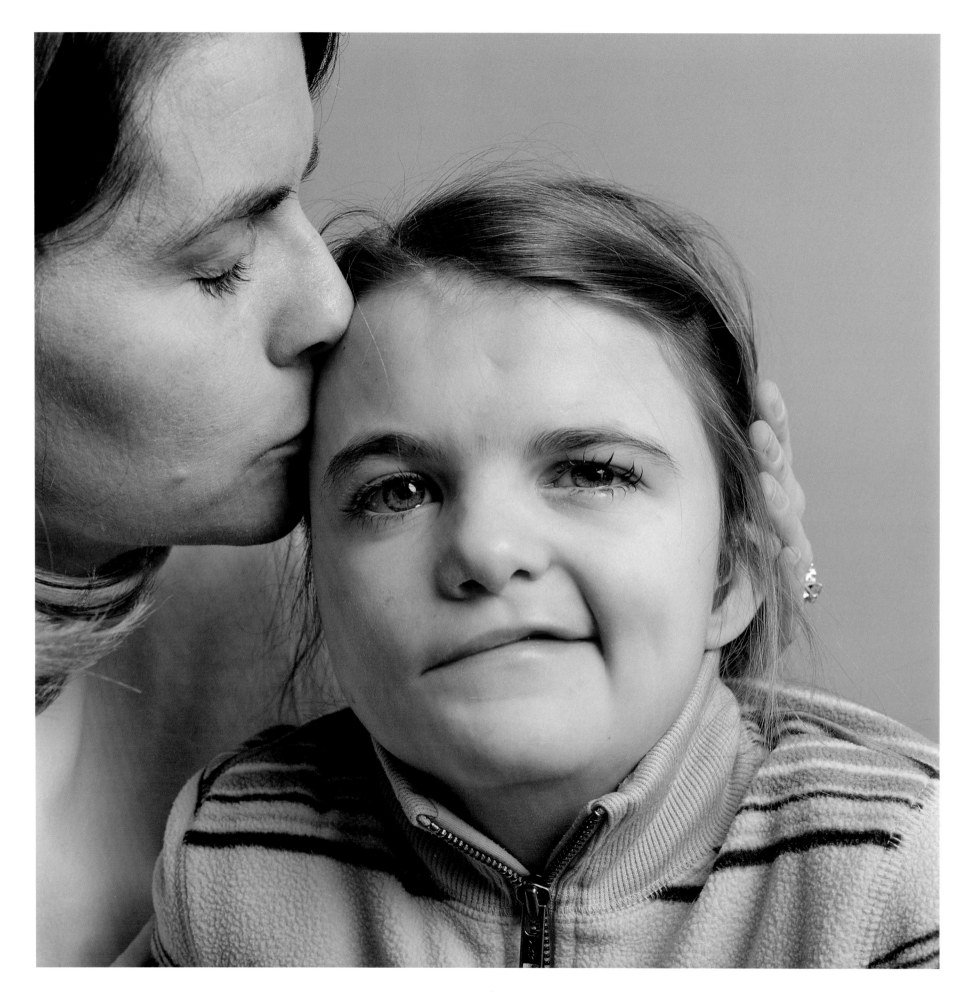

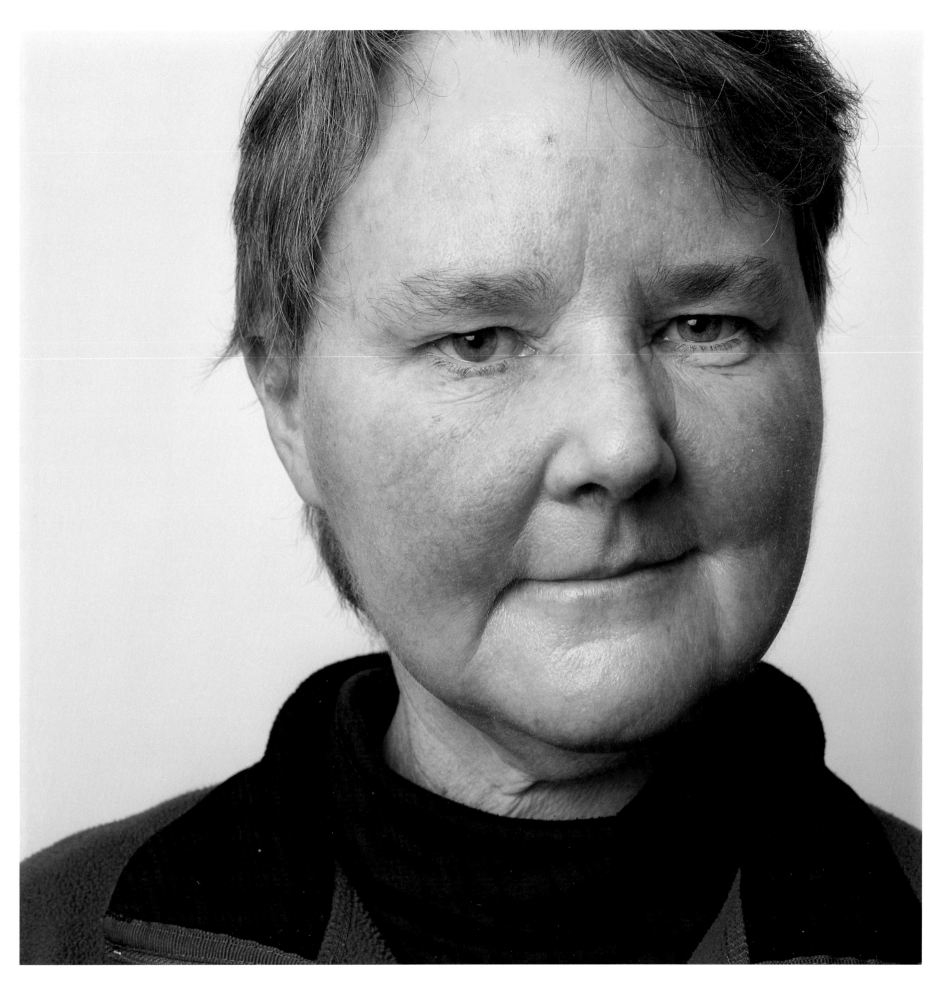

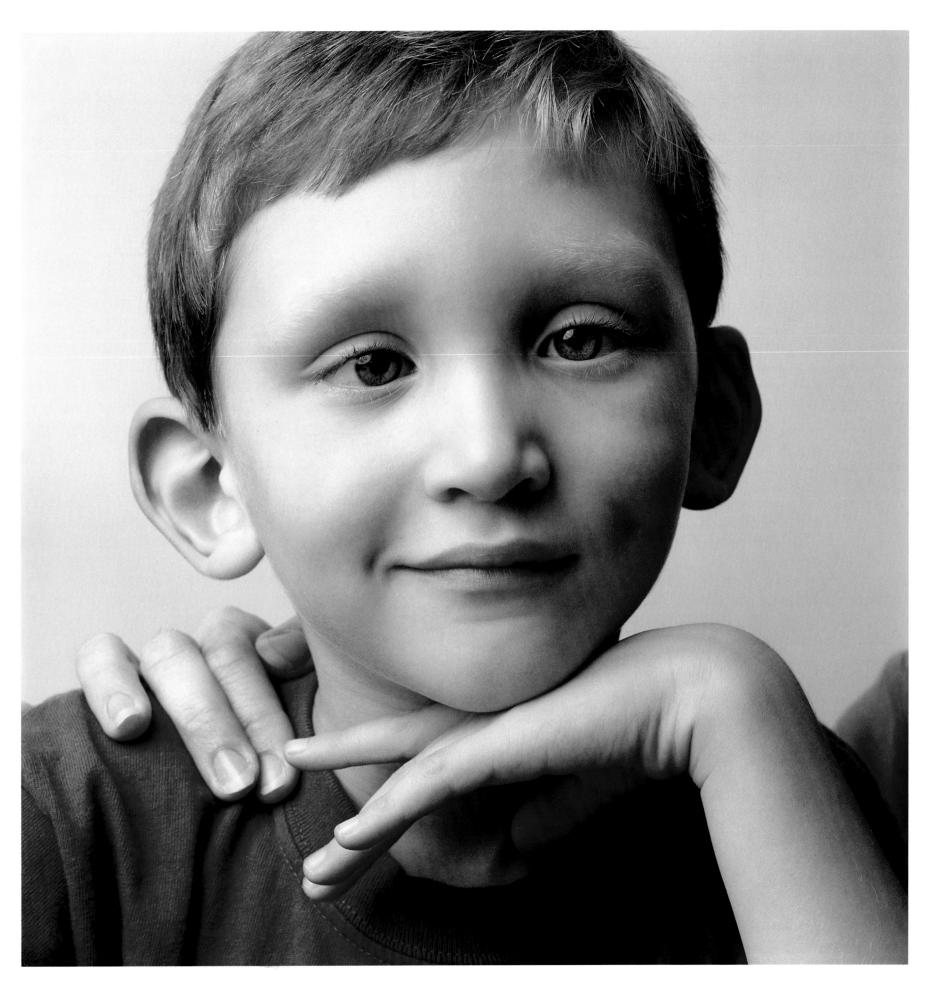

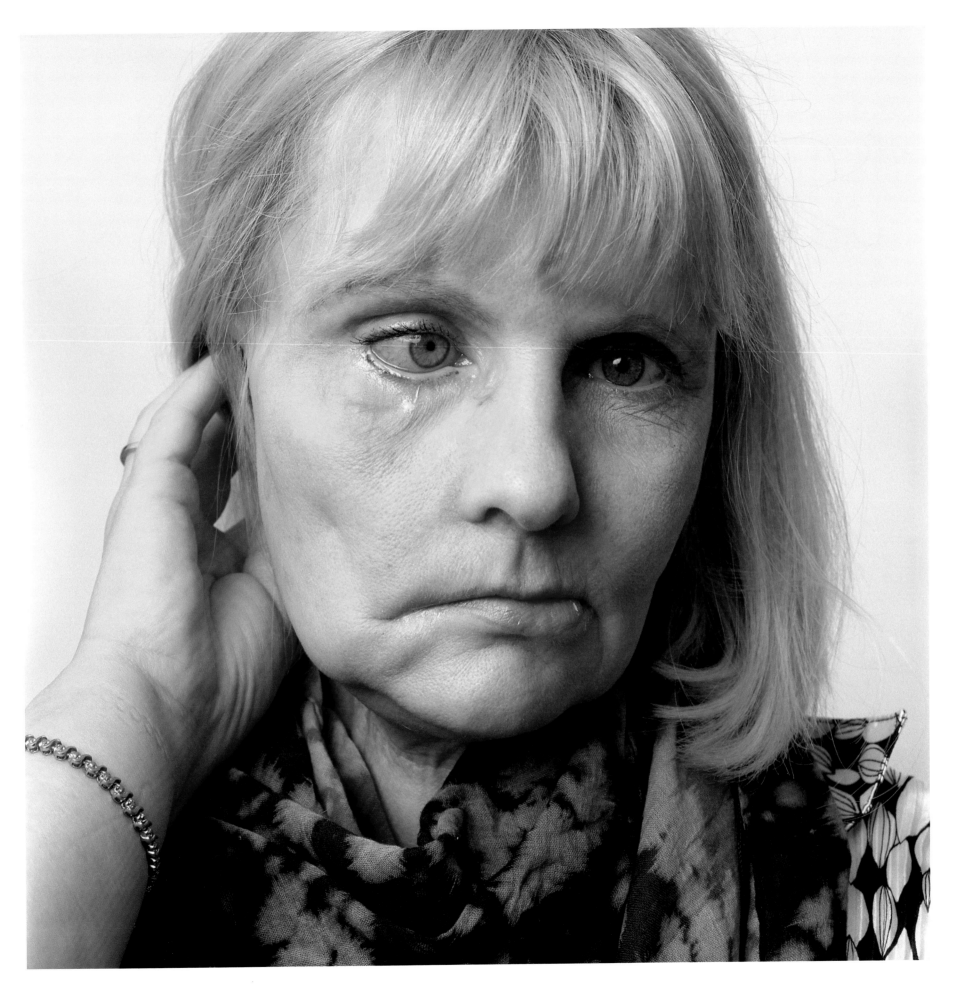

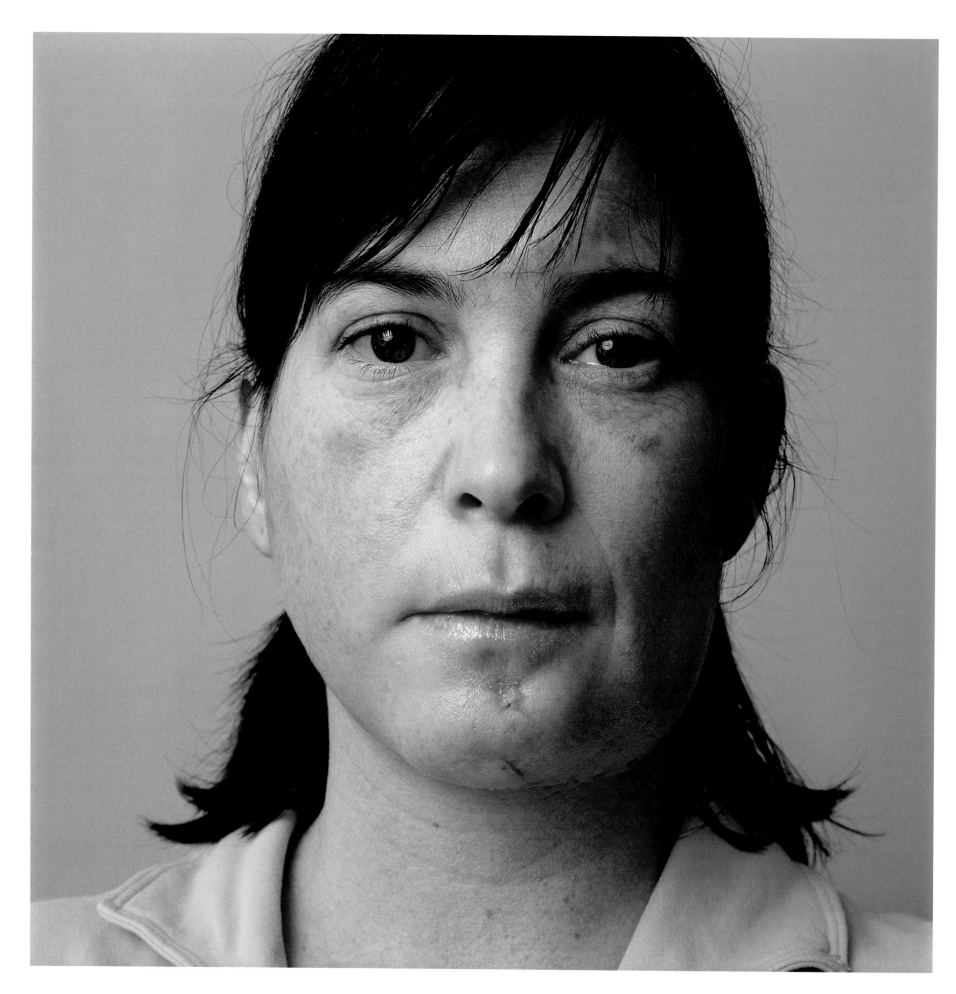

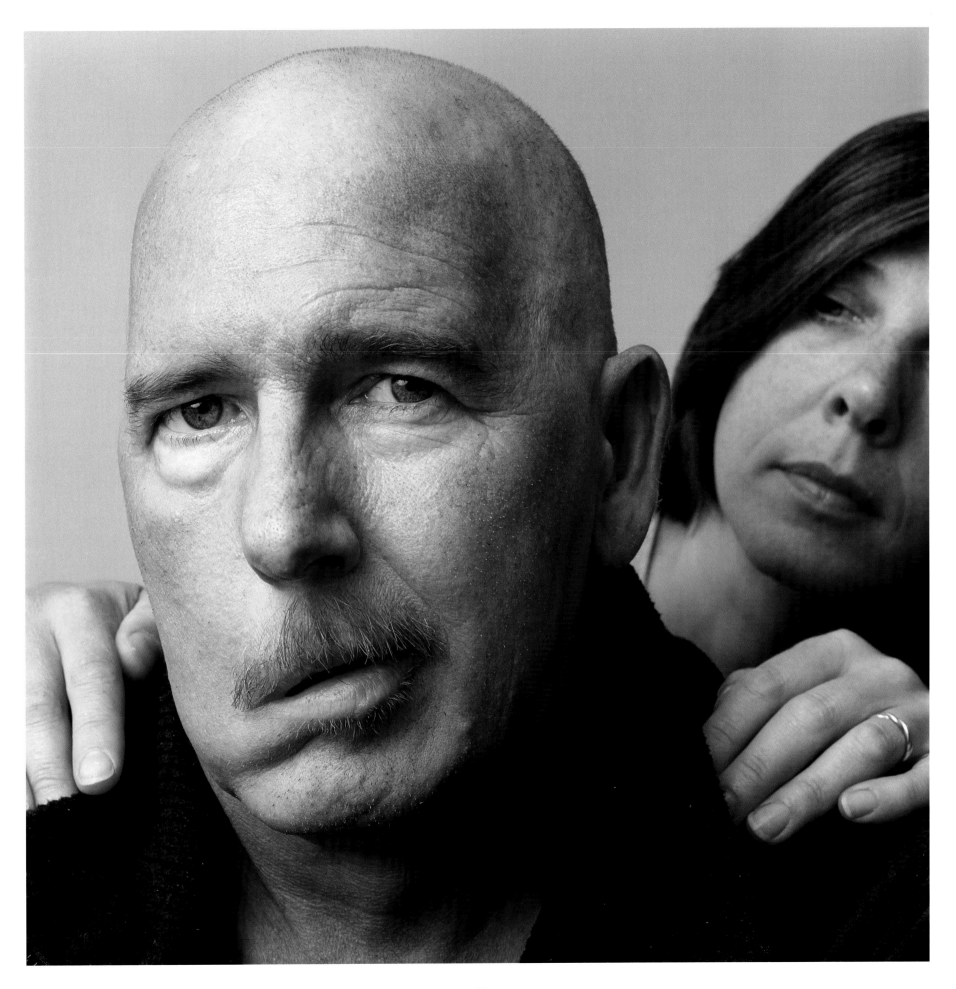

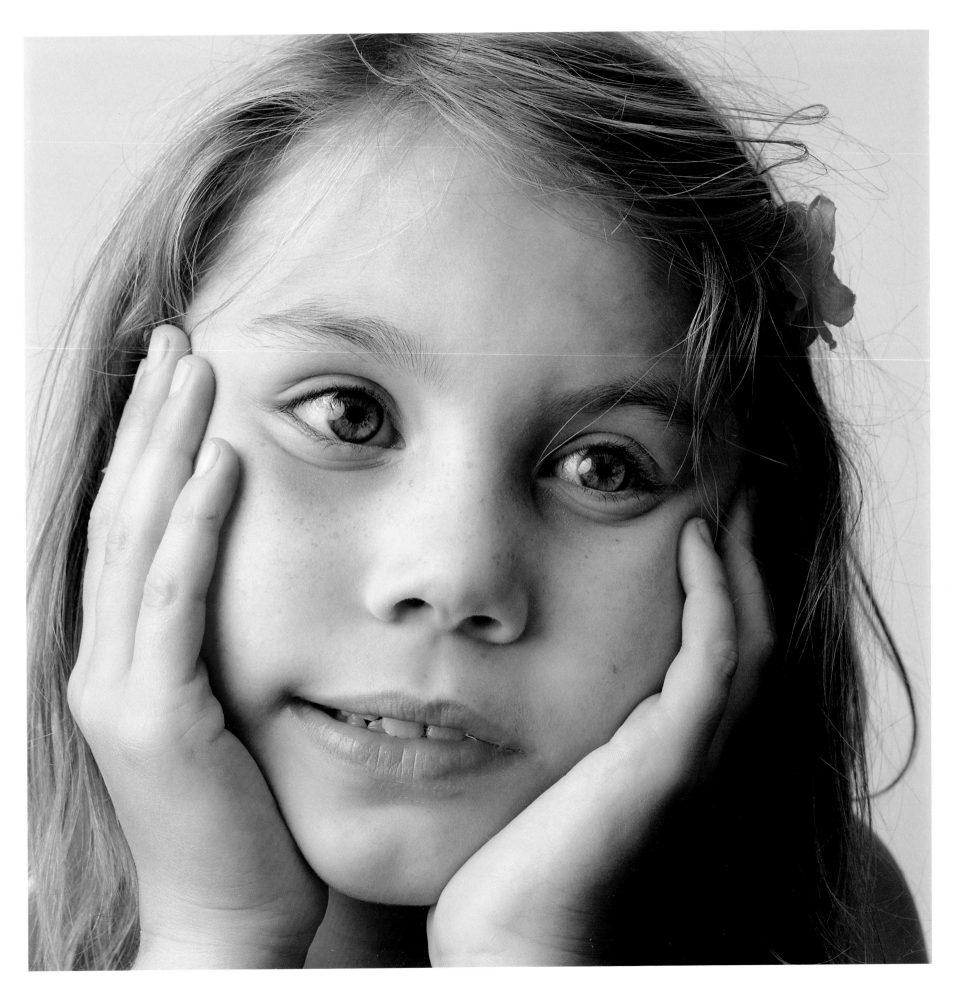

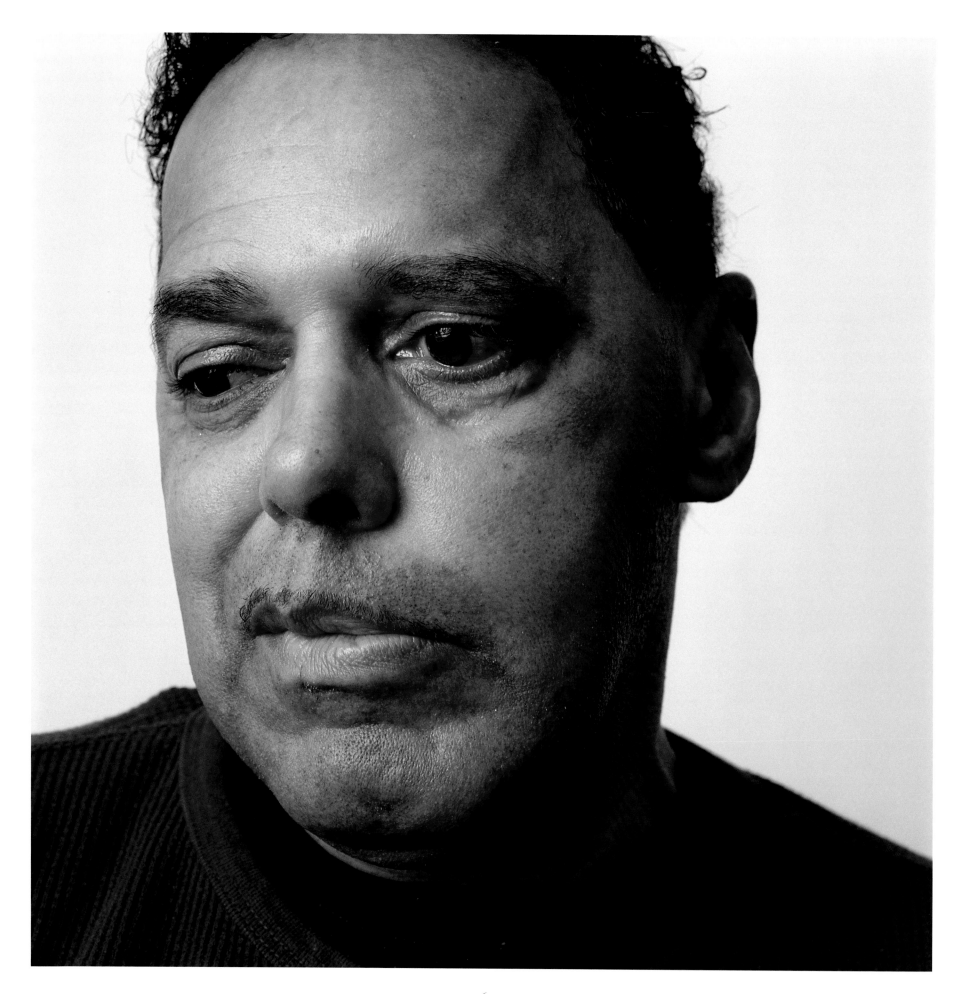

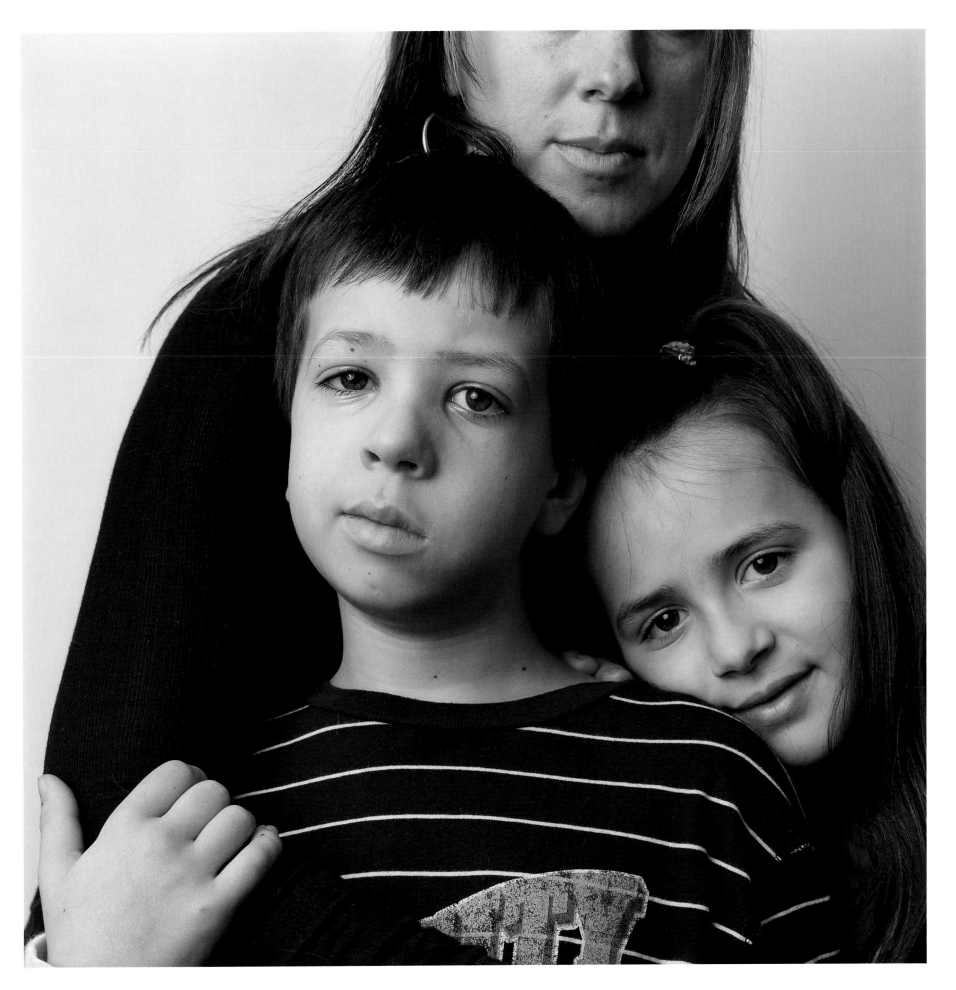

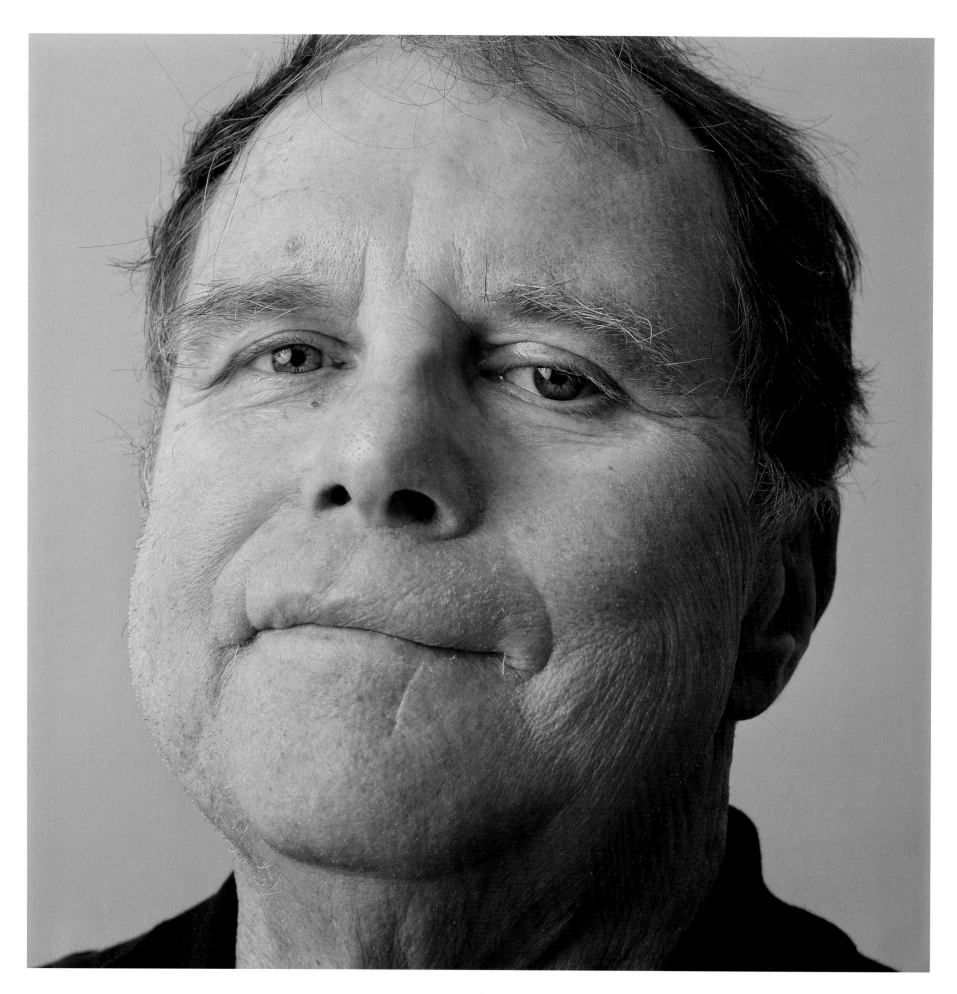

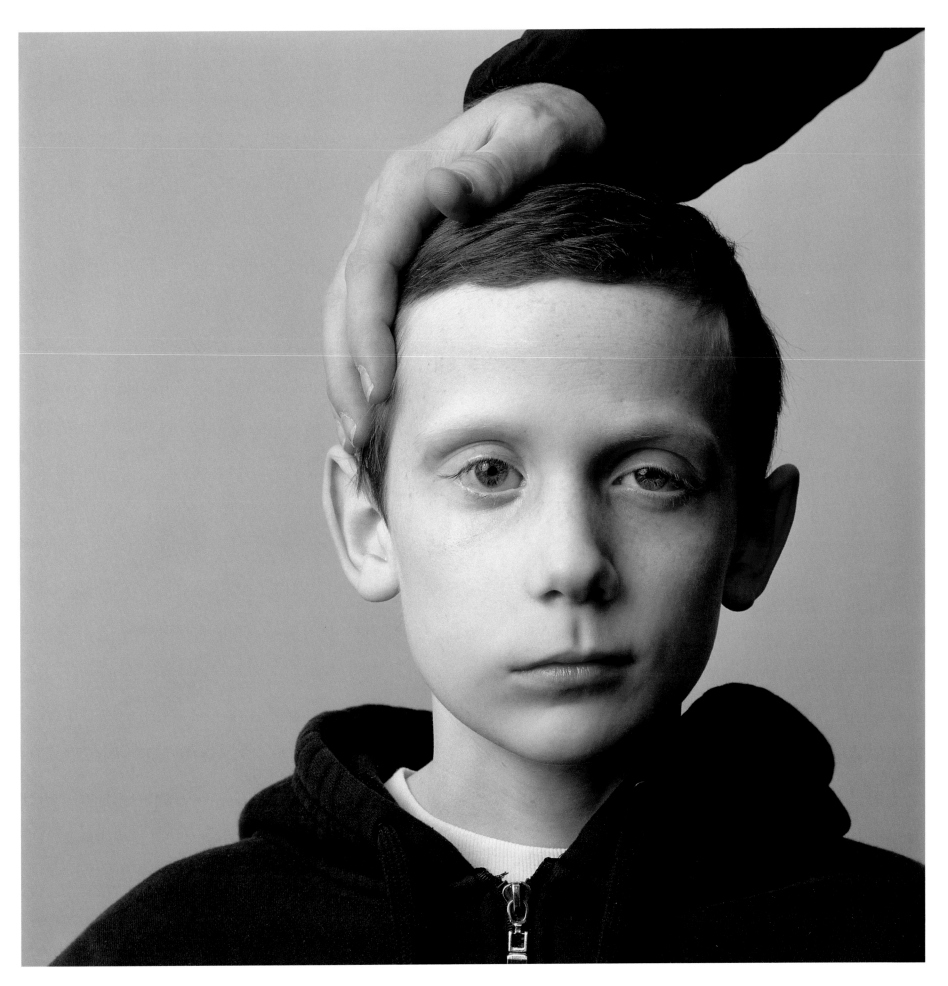

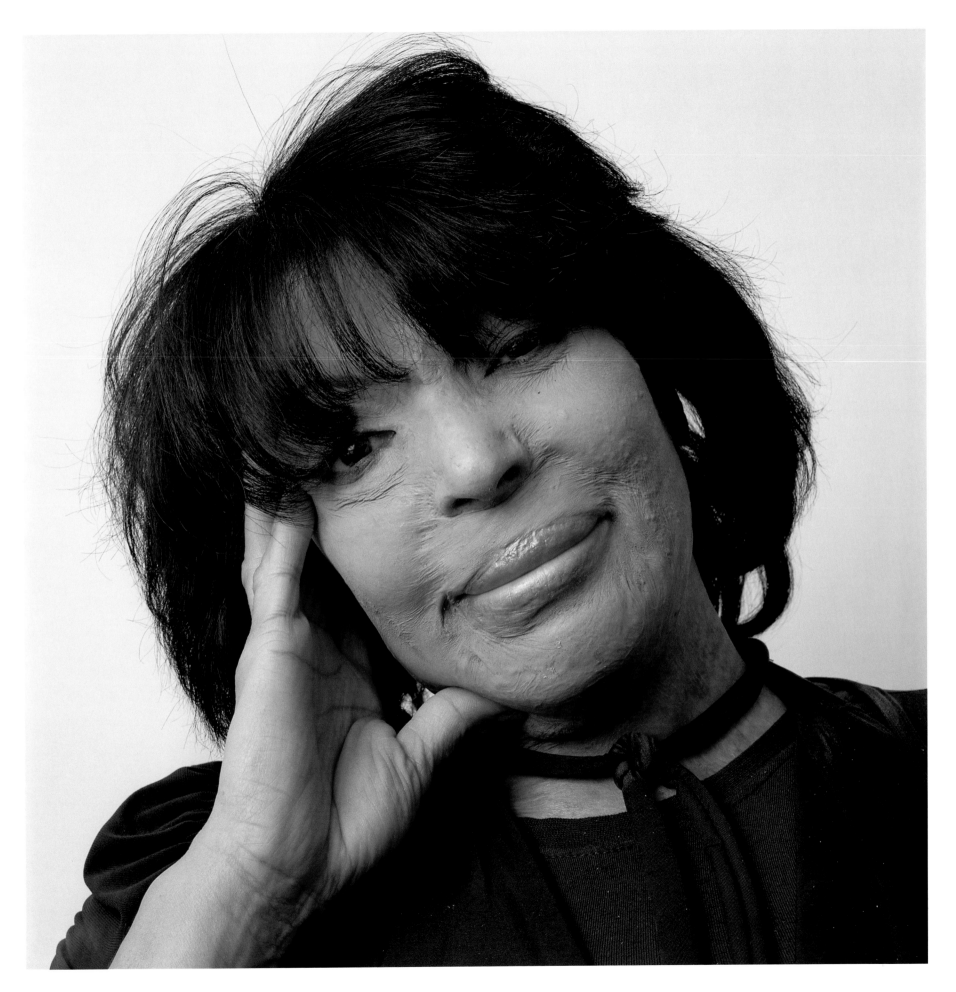

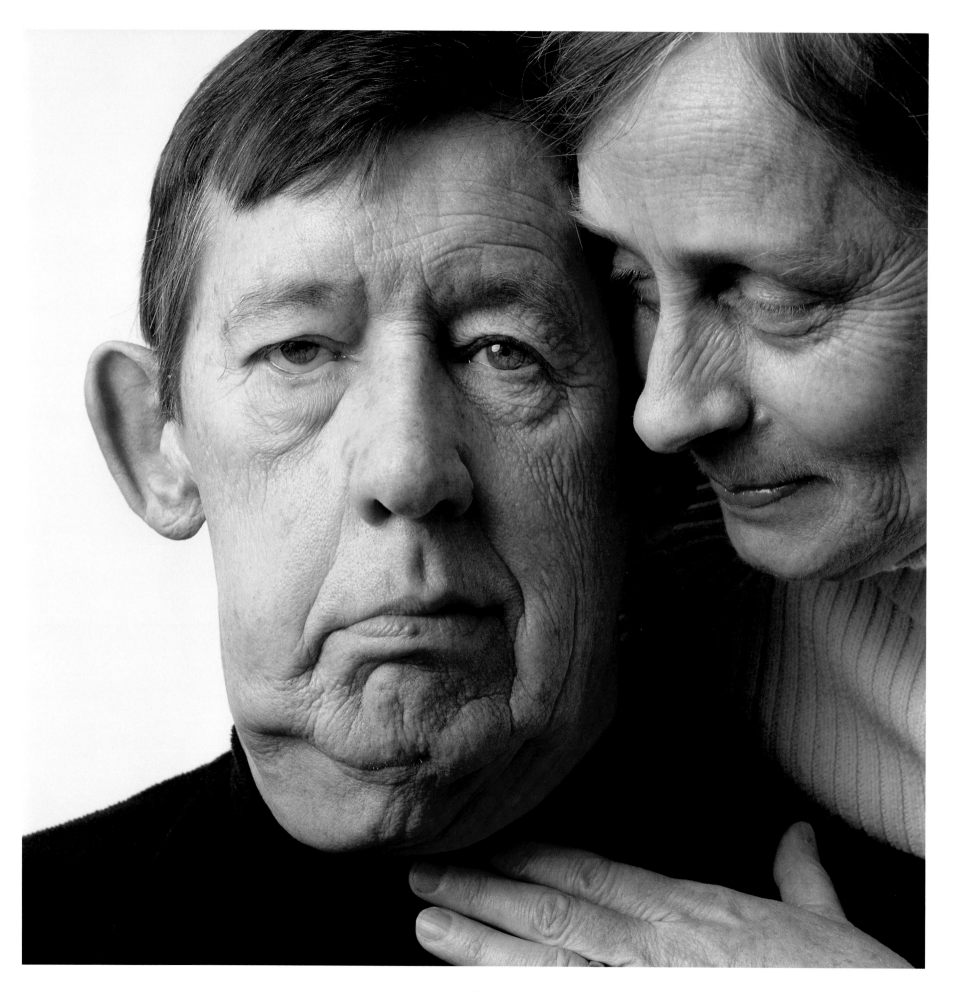

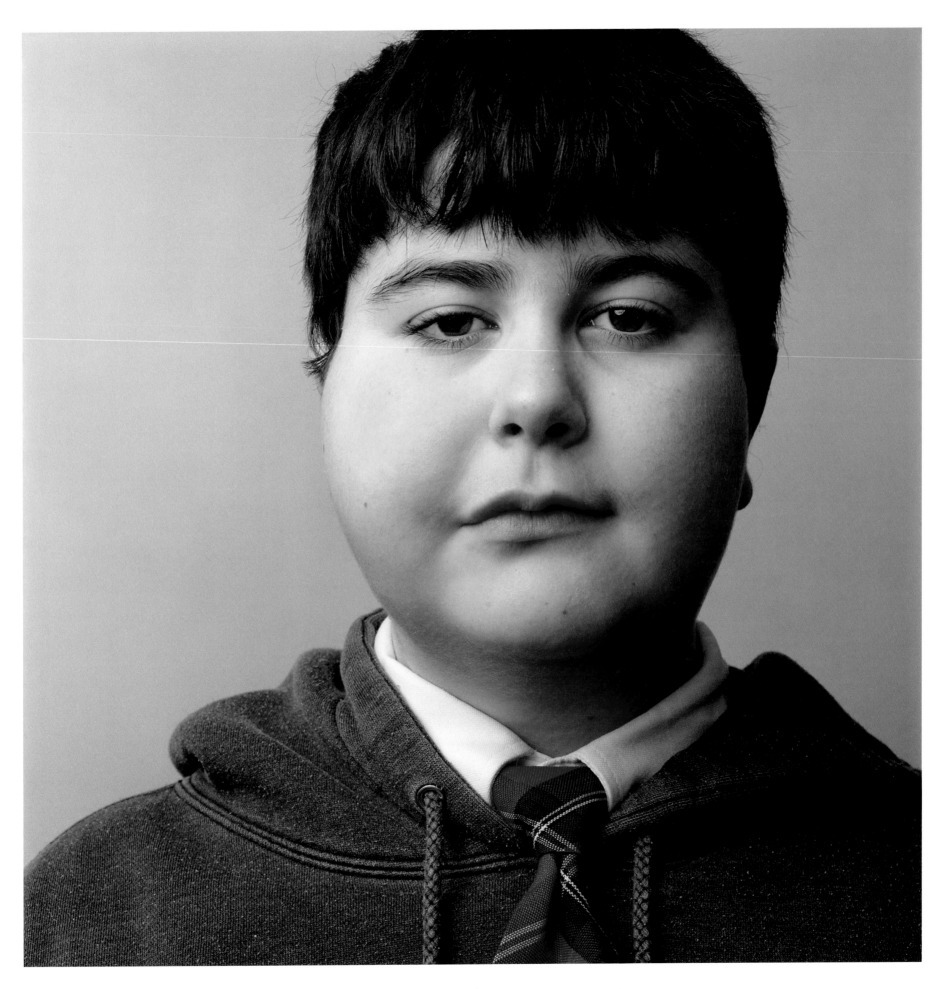

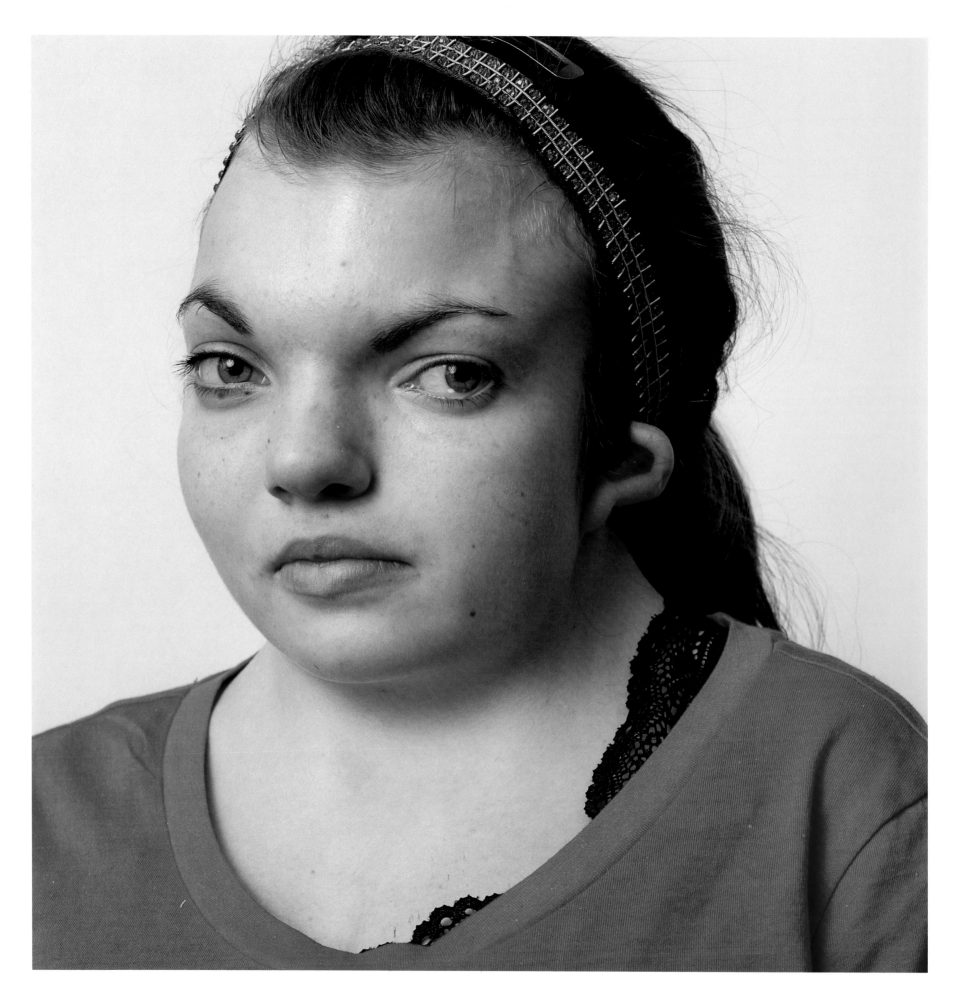

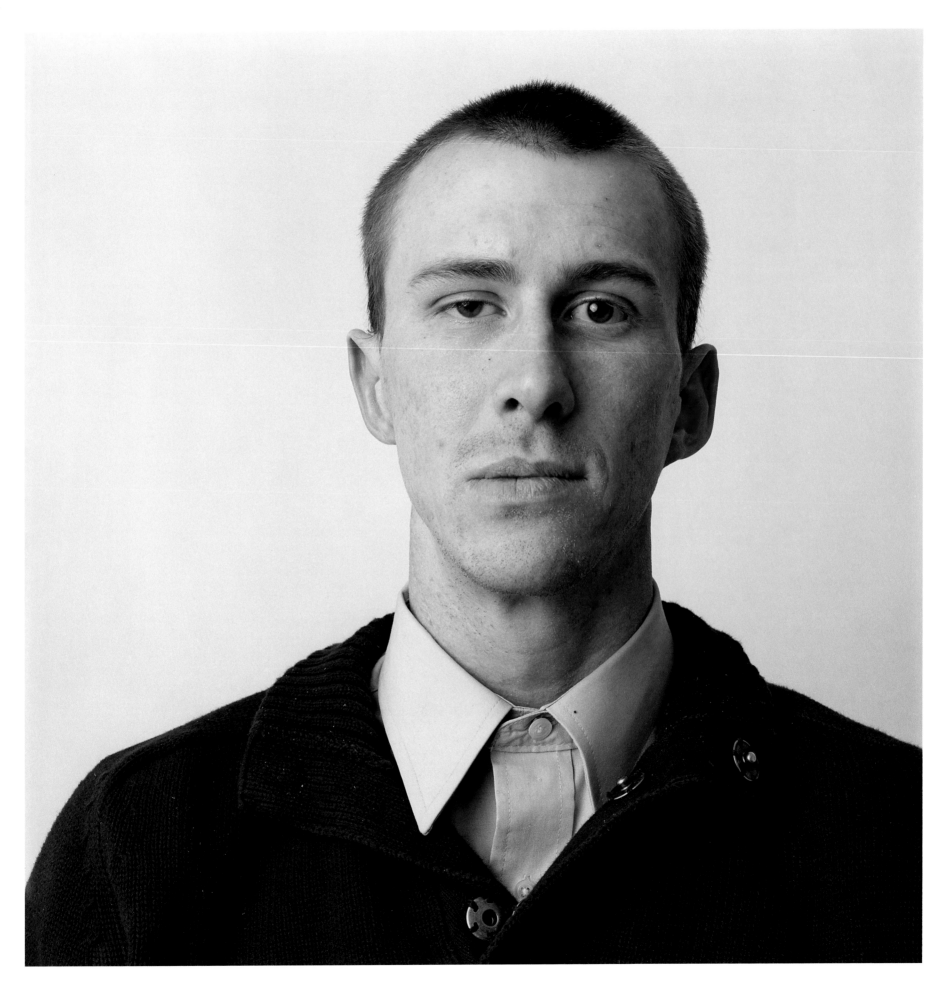

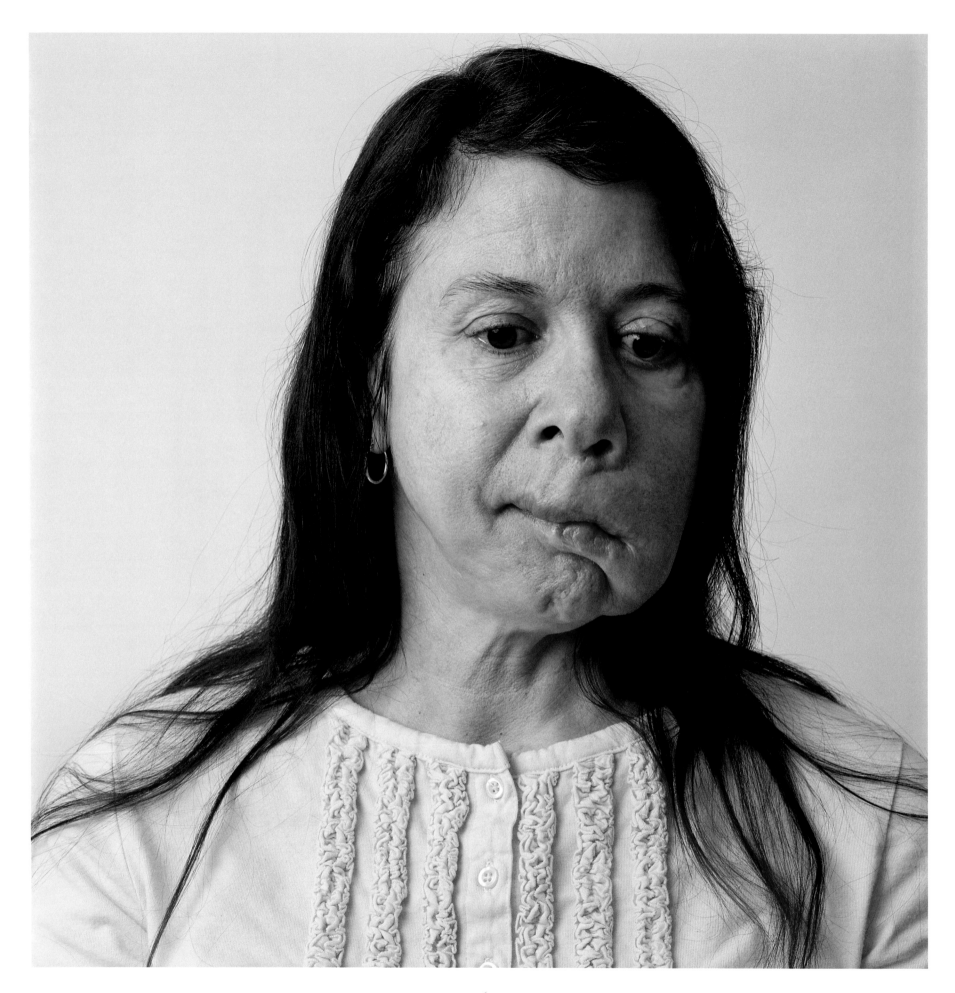

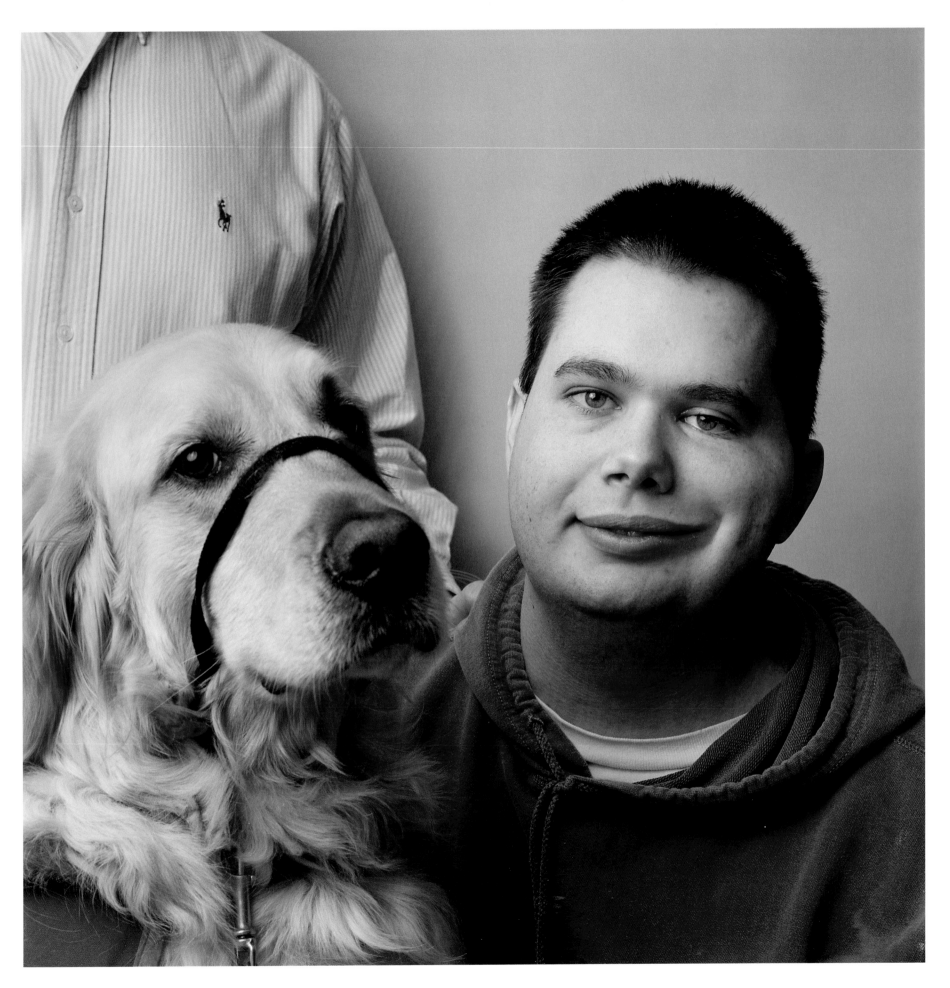

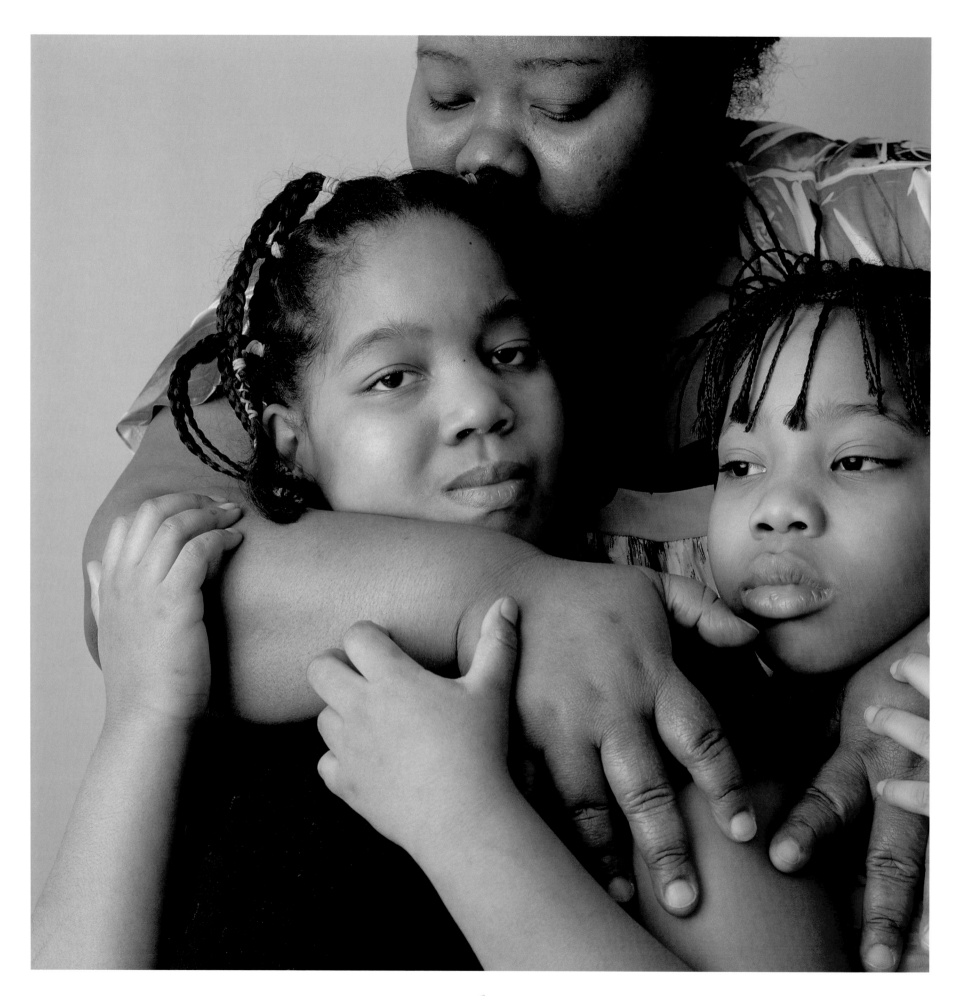

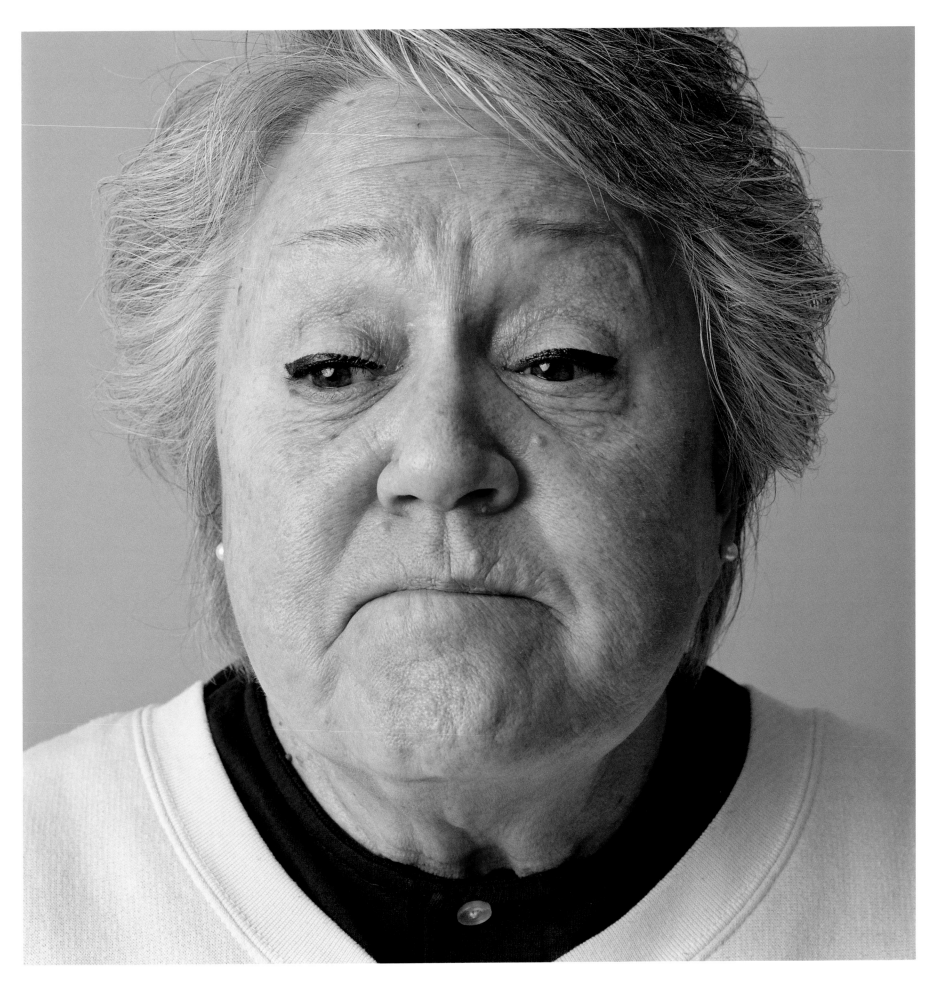

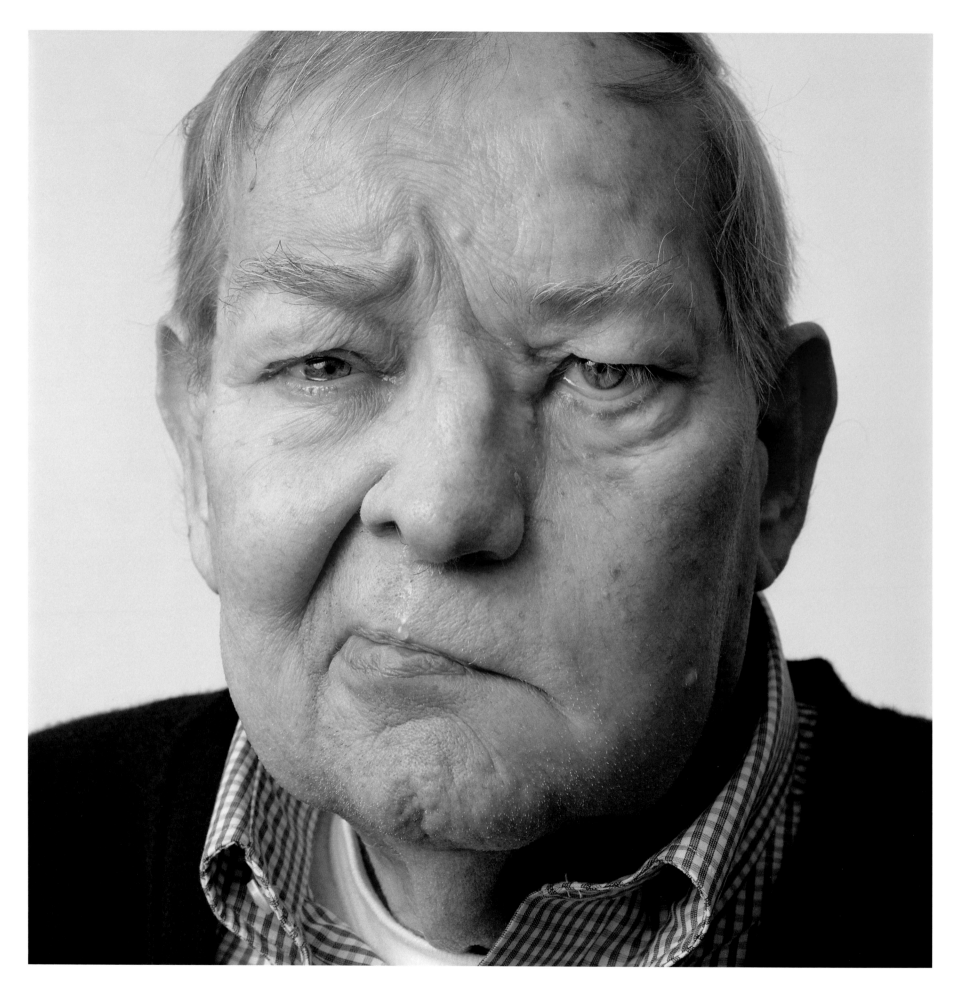

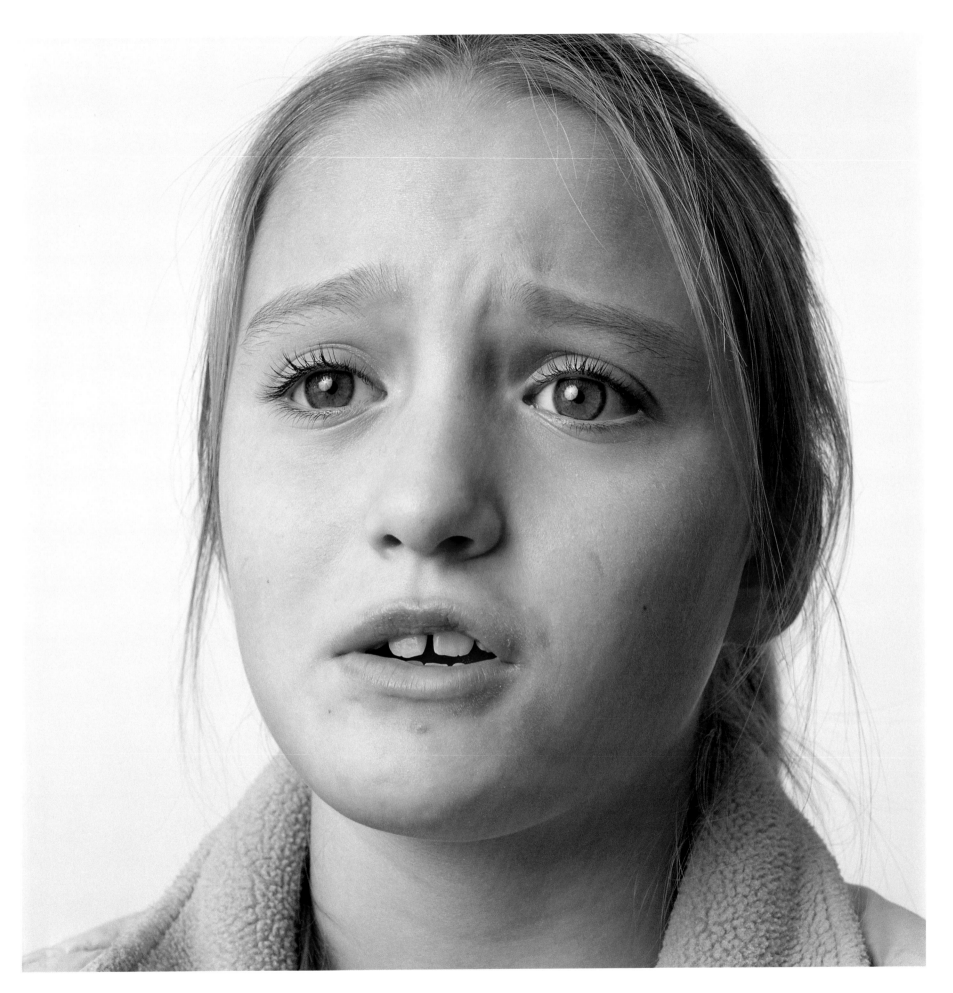

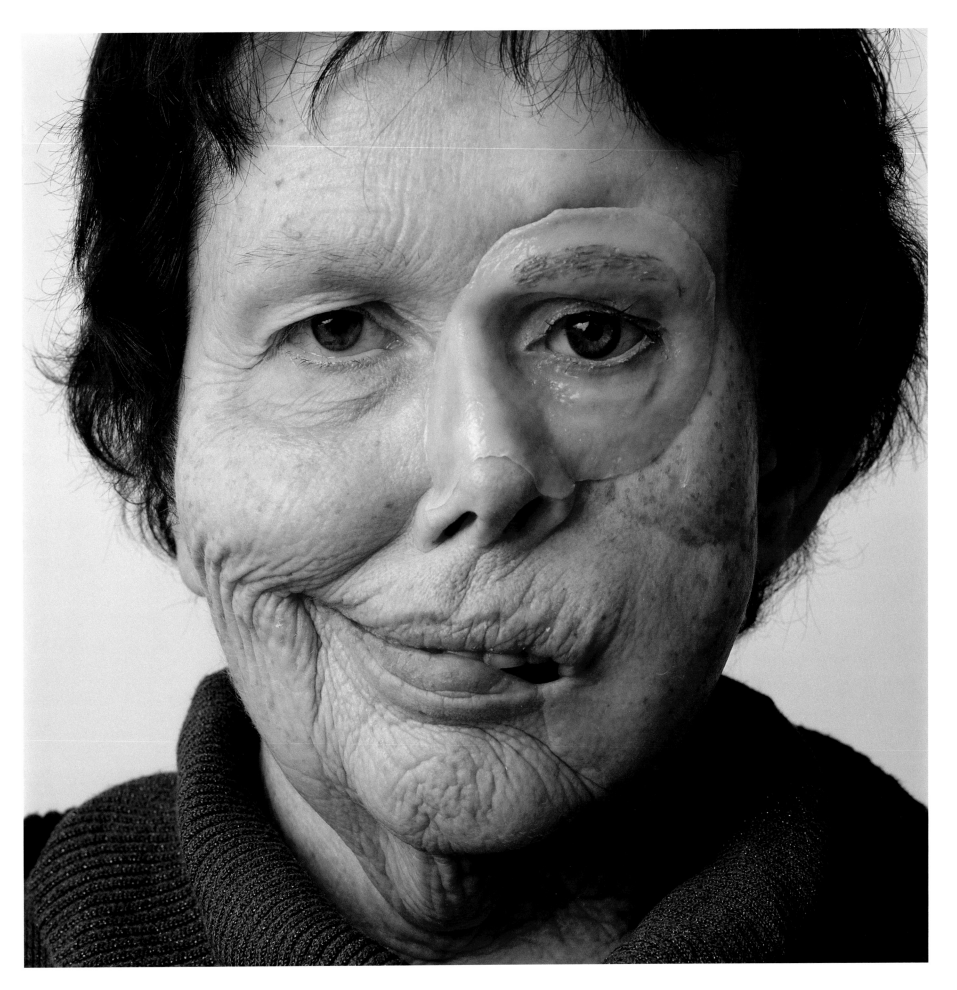

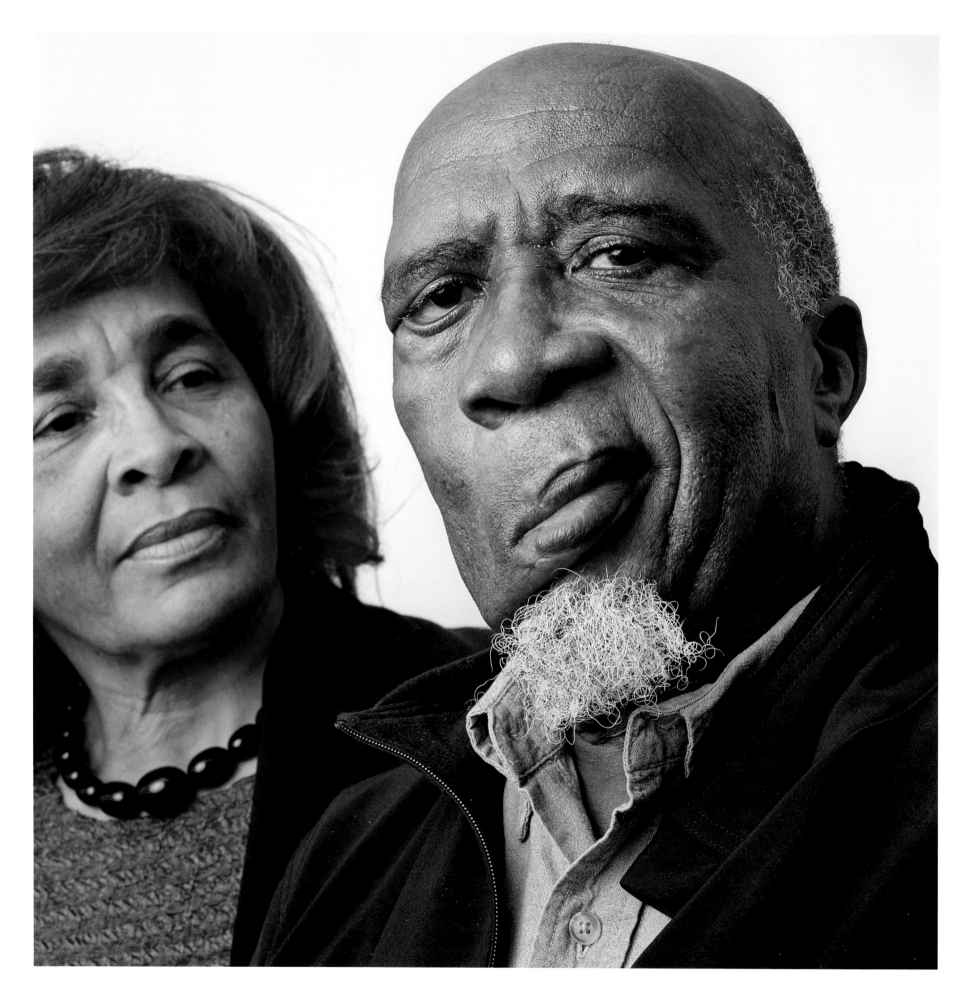

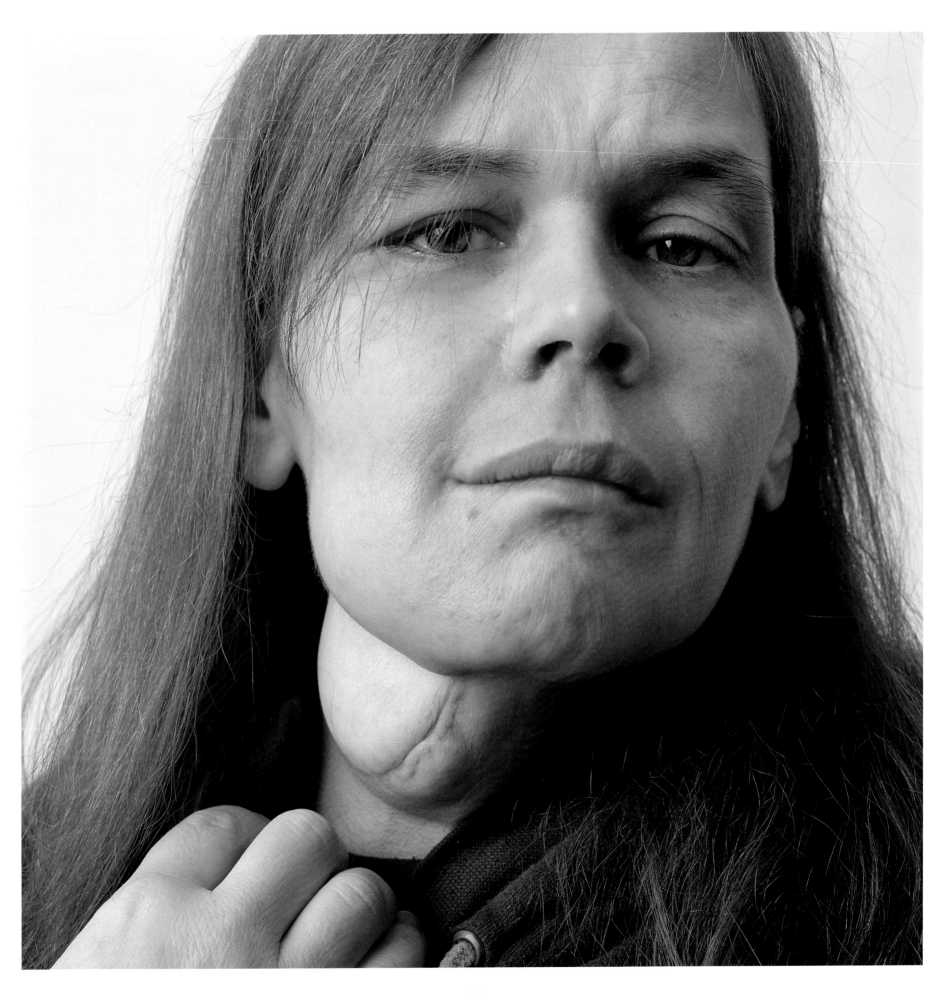

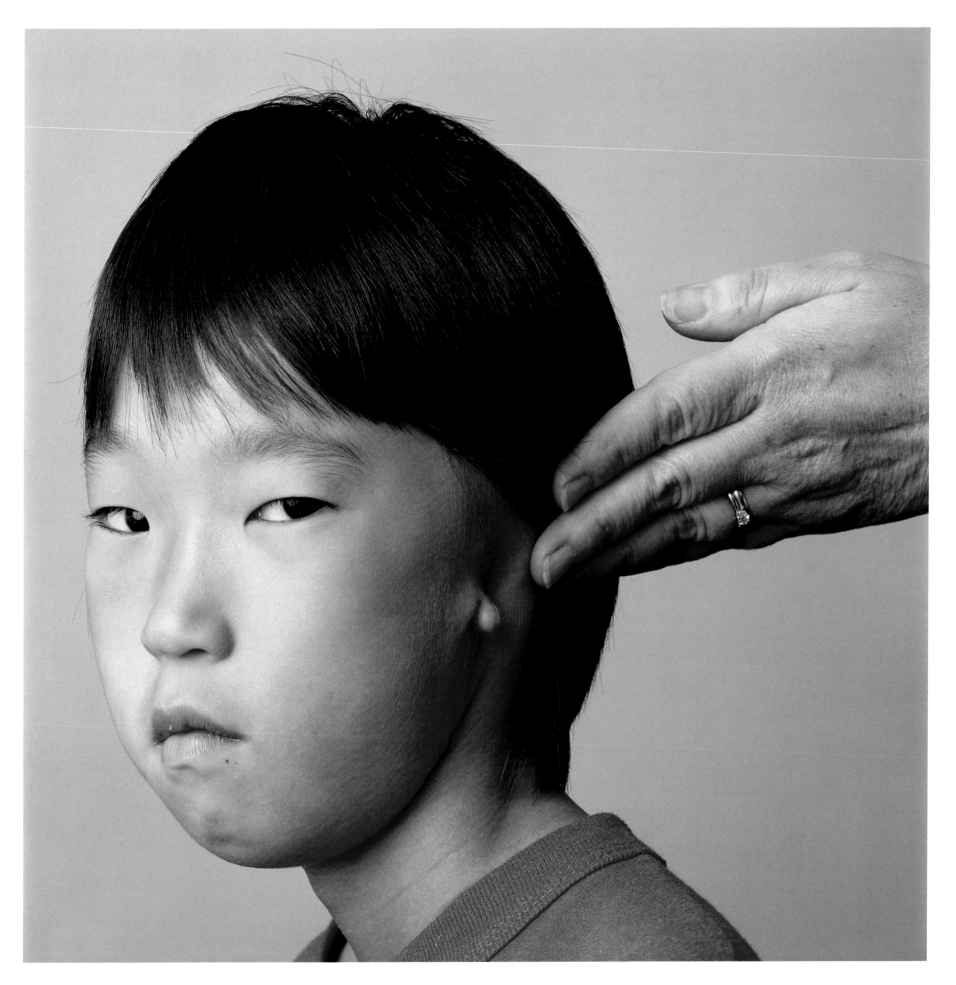

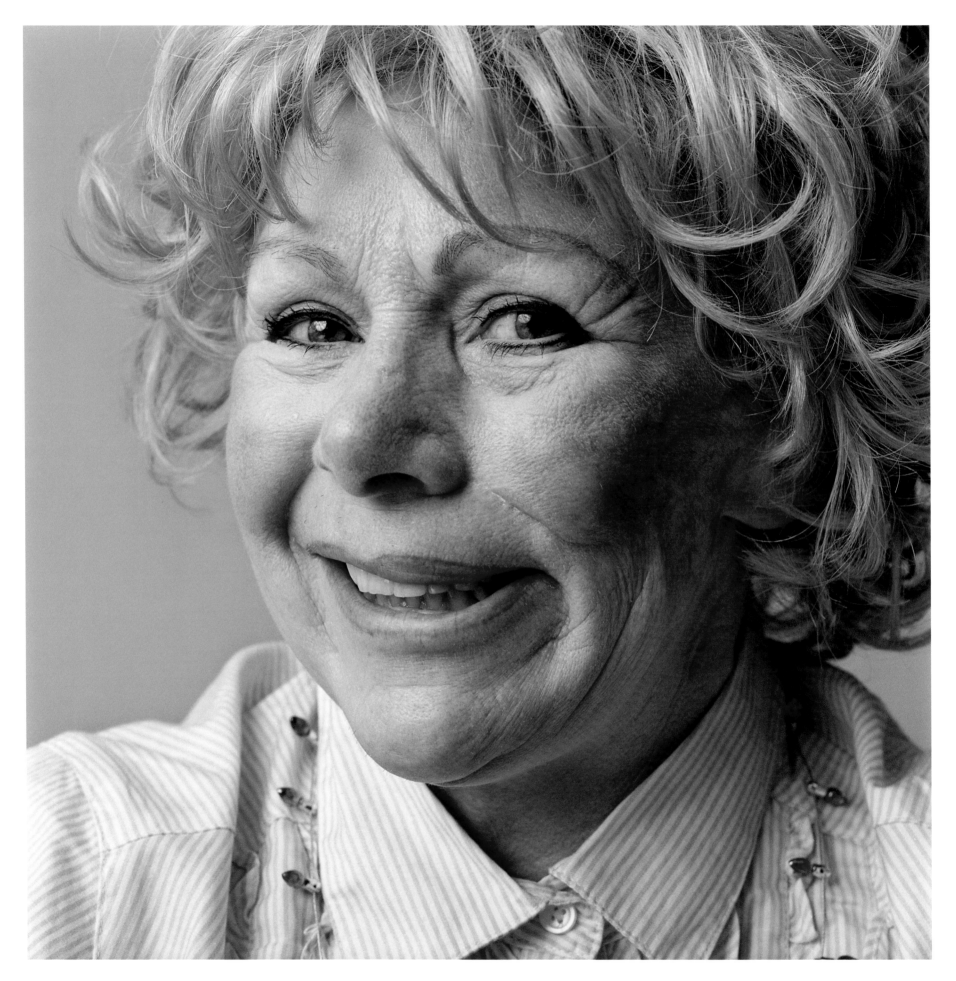

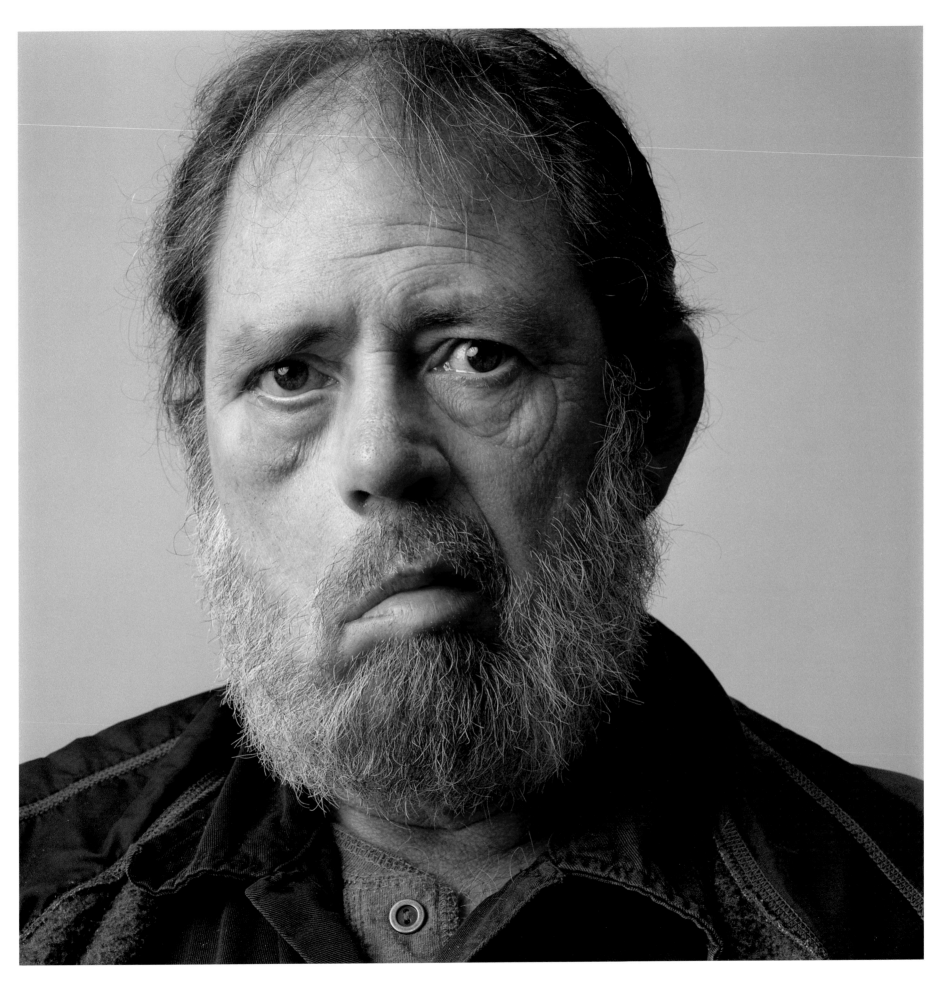

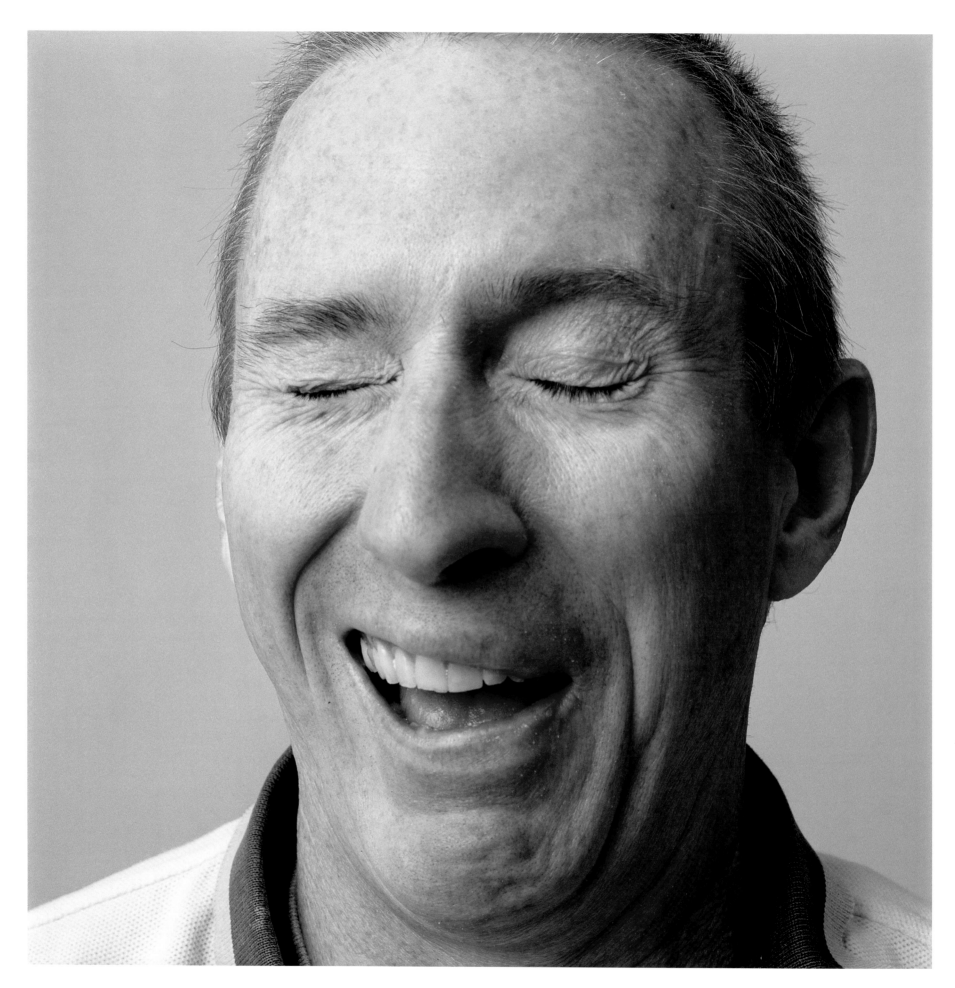

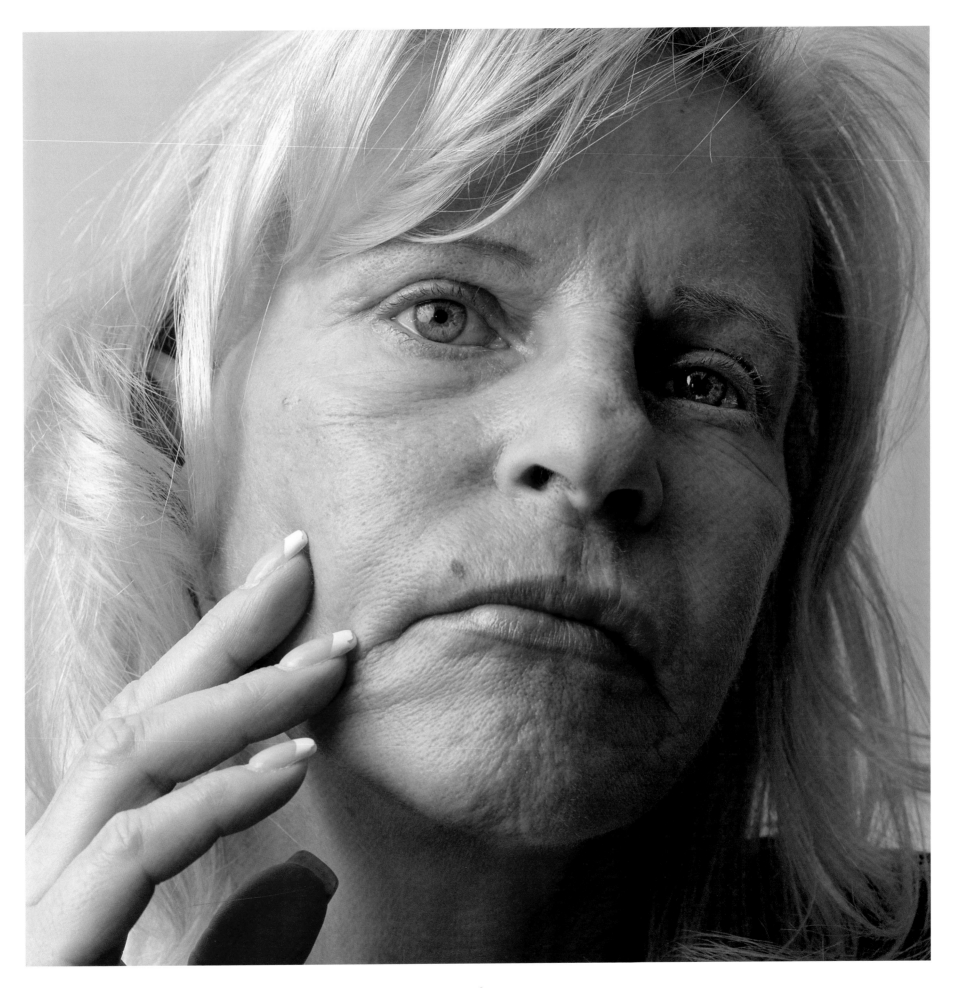

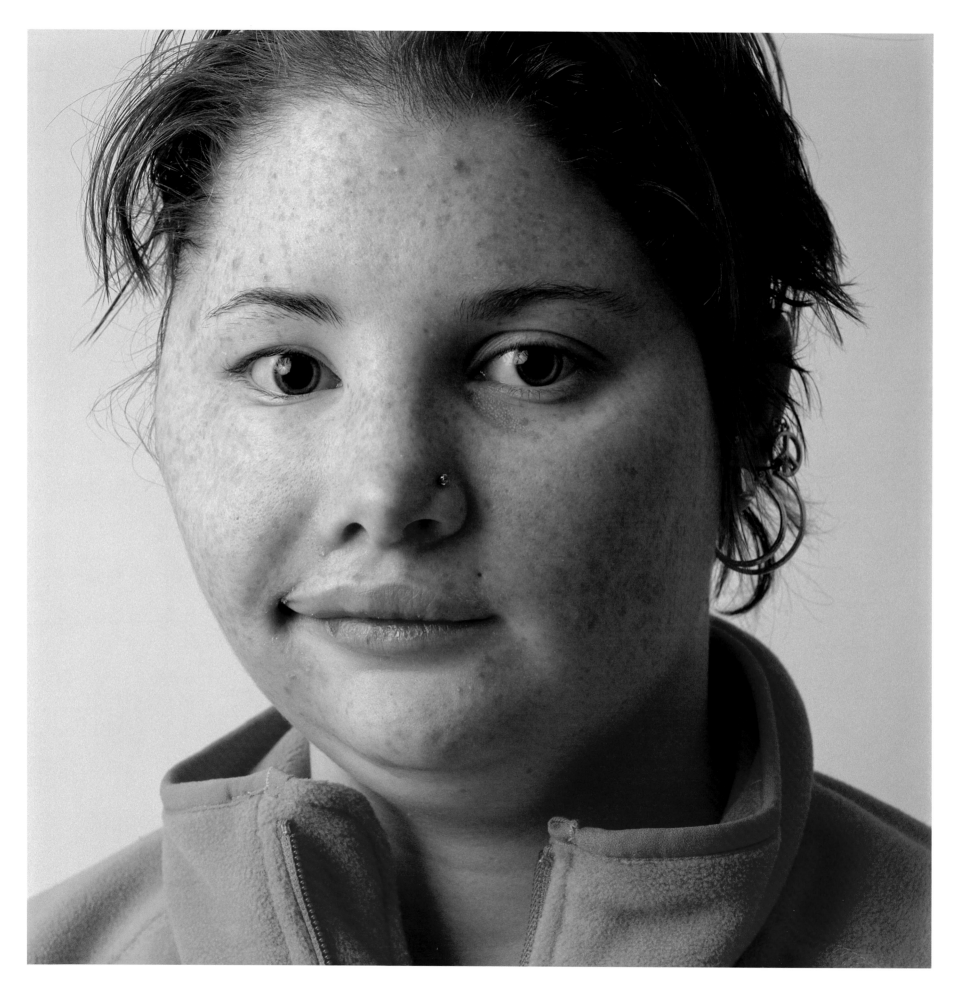

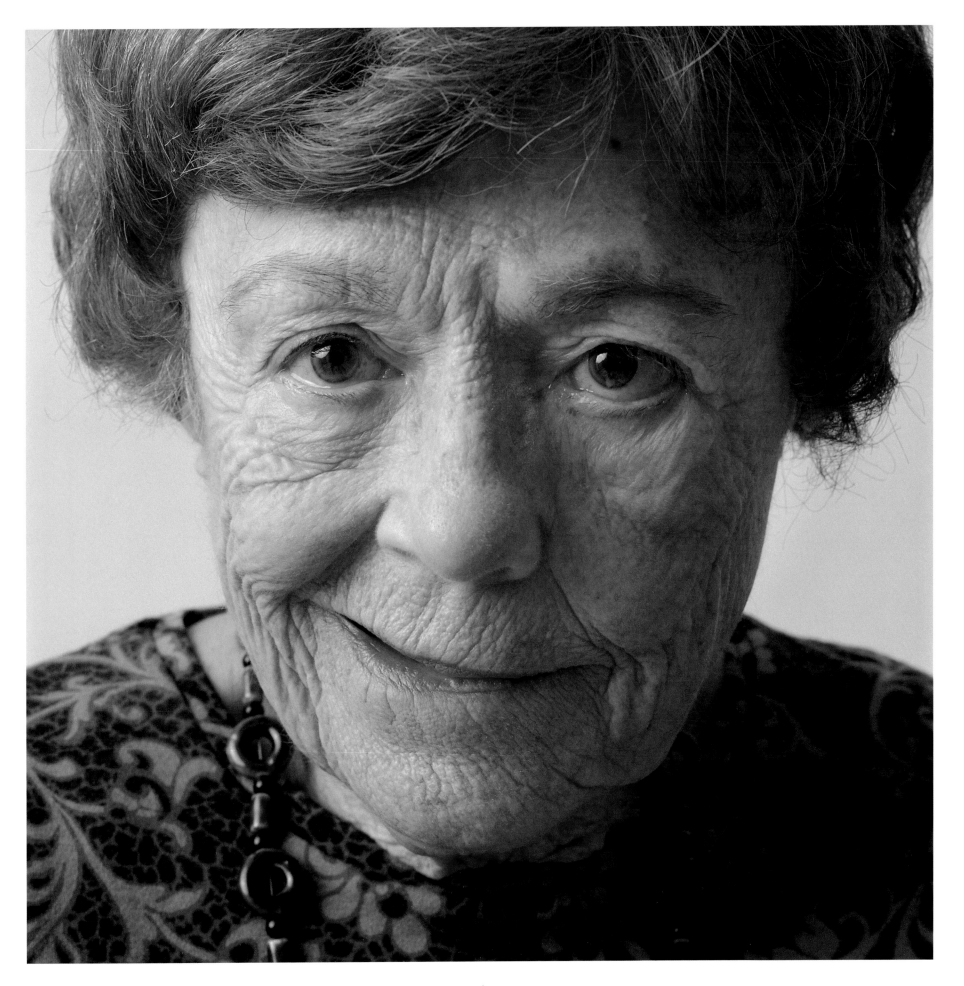

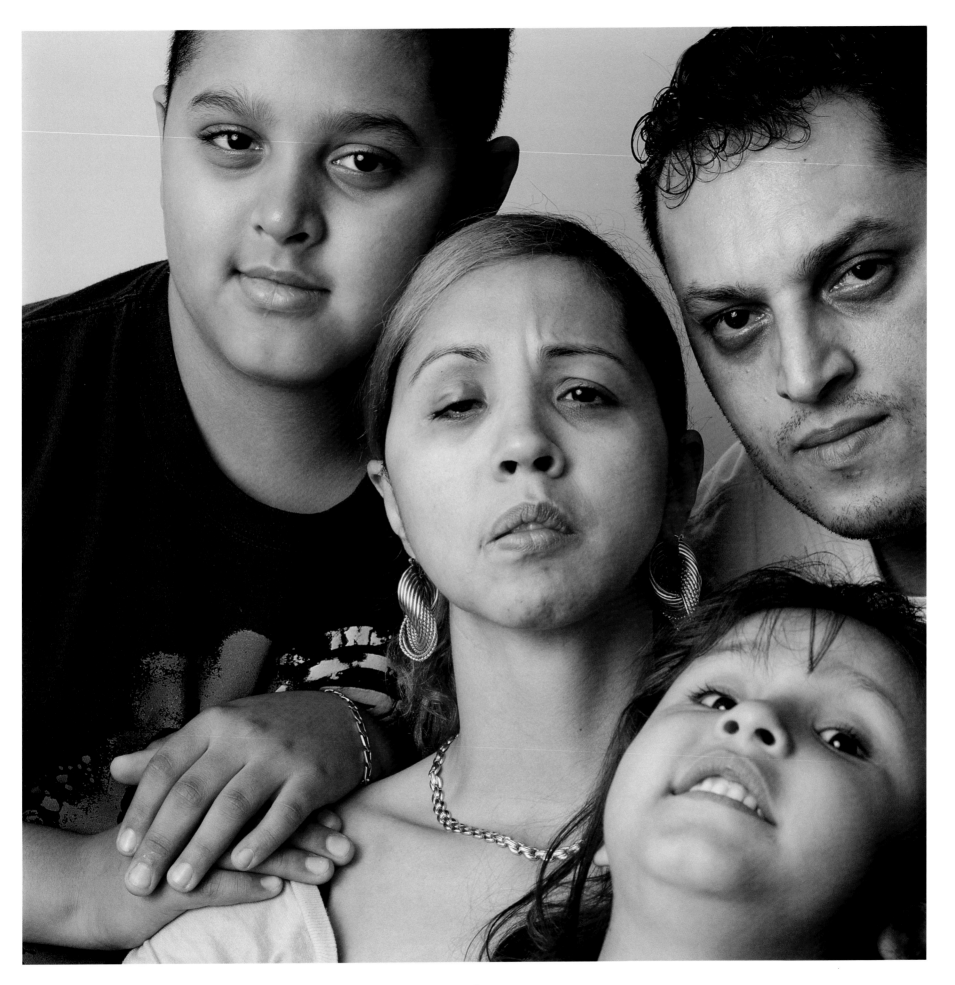

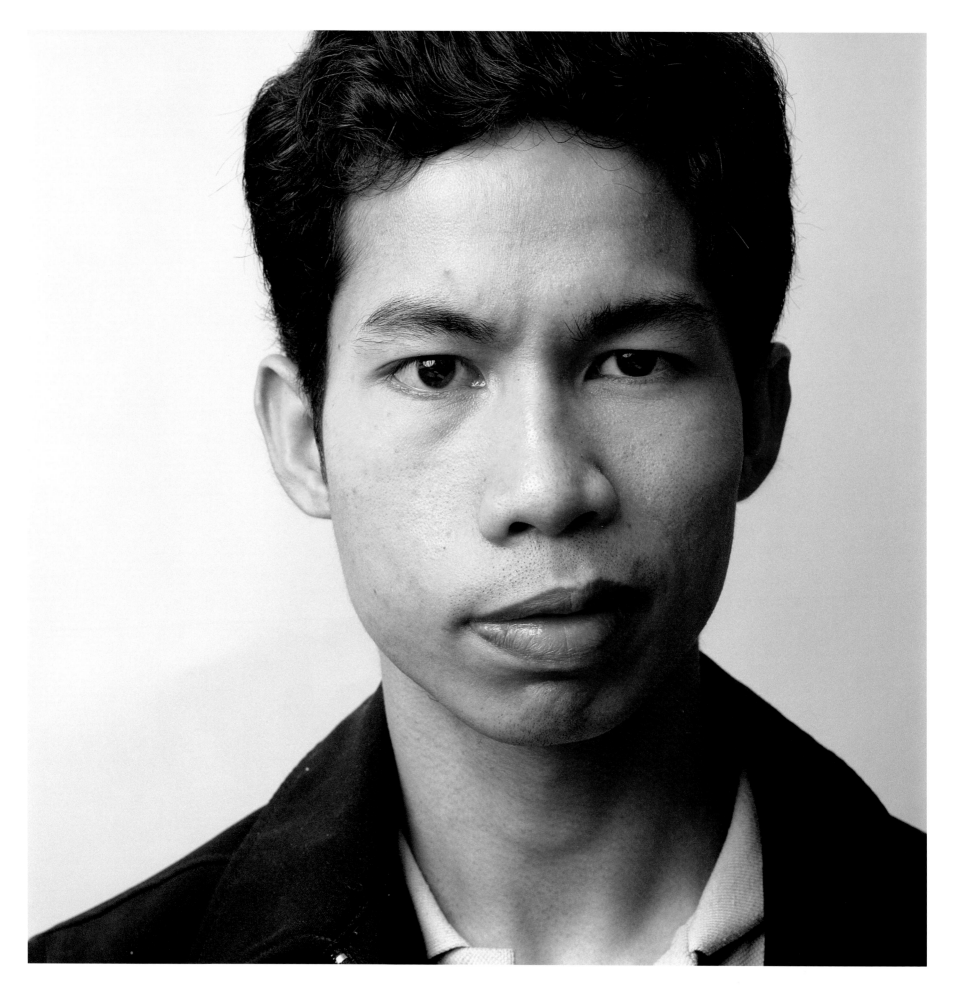

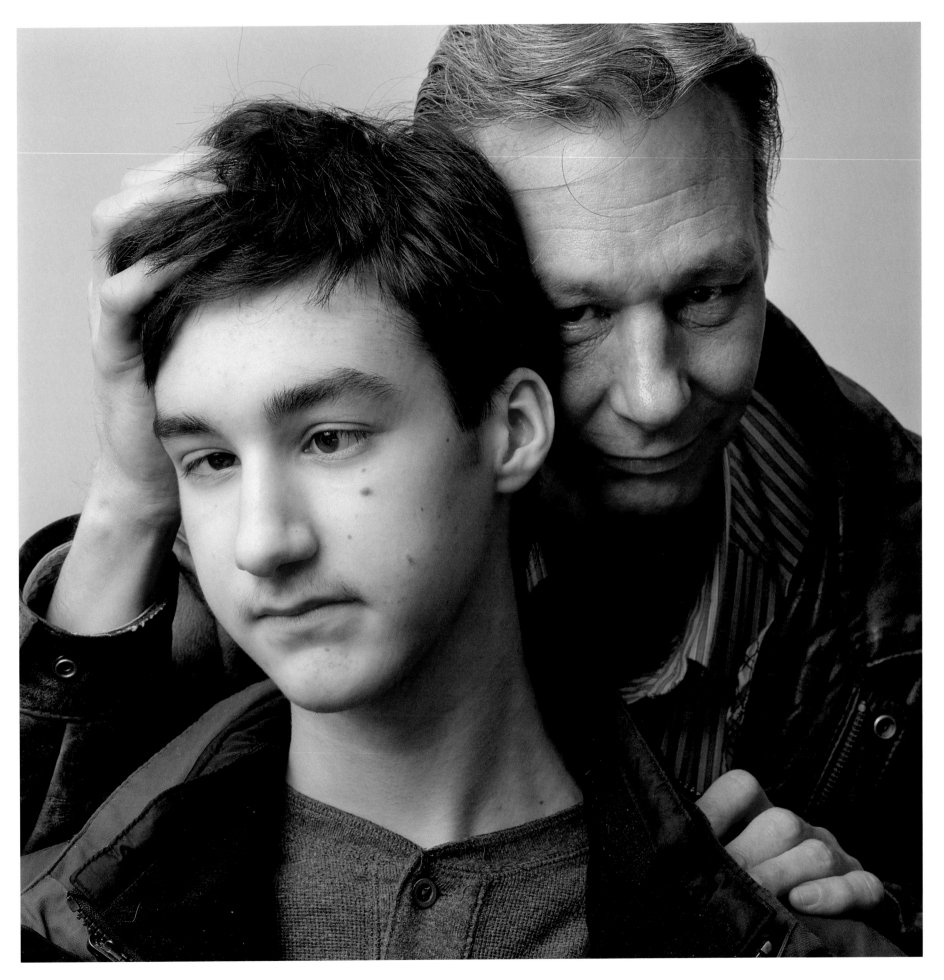

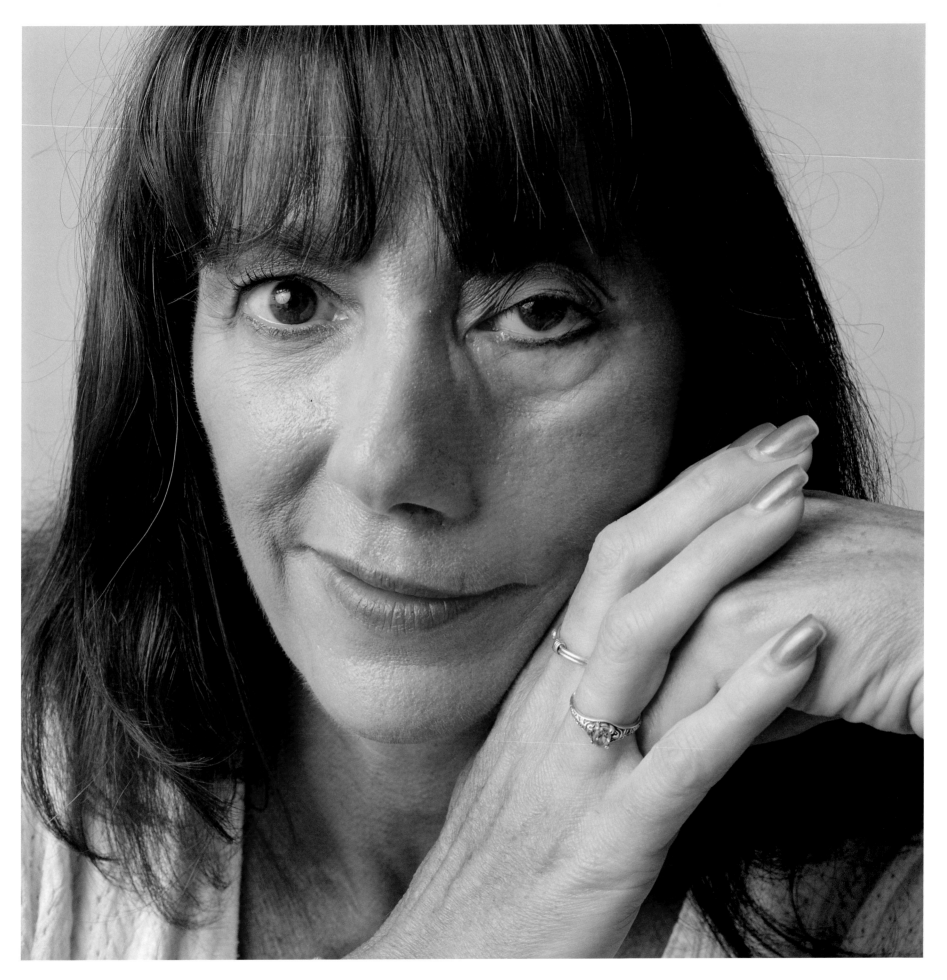

CAUSES OF FACIAL PARALYSIS

Most people who encounter someone with facial paralysis assume that he or she has either had a stroke or has Bell's palsy. However, there are many different causes. Of the people whose photographs are included in this book:

- Five of them had Bell's palsy. Some of them had a recent onset, others had suffered its effects for years; in one young girl it was caused by Lyme disease.

- Four had acoustic neuromas—slow-growing tumors of the nerve that connects the ear to the brain.

- Seven (mostly children) had brain tumors (some malignant, some benign).

- Four had salivary gland tumors (parotid tumors).

- Three had been in car accidents.

- Four were born with (congenital) facial paralysis.

- Three had iatrogenic facial paralysis (caused inadvertently by an earlier surgery or medical treatment).

- One person had had a stroke, caused by arteriovenous malformation (she was born with an abnormal connection between veins and arteries).

- Two children had microtia (they were born with an incompletely formed ear), as well as related facial nerve problems.

- Two had facial paralysis from unknown causes (they had not yet been diagnosed).

In addition, one young woman had had meningitis as a two-year-old; another woman had Ramsay Hunt Syndrome (an outbreak of Shingles near the ear); another had developed facial paralysis after radiation for keloids (excess growth of scar tissue). One child had CHARGE syndrome: a genetic pattern of birth defects, including heart defects and breathing problems. Another child had suffered facial trauma from a fall. One woman had had a glomus jugulare tumor (a benign tumor of the temporal bone in the skull) removed twenty years earlier. Another woman had been burned with acid, which also caused facial nerve damage. Another had a benign tumor surrounding a nerve (plexiform neurofibroma). A man had an angiosarcoma (a malignant tumor) removed. Another man had a chondrosarcoma (a common form of bone cancer) removed. An older man had metastatic prostate cancer. A woman had a sebaceous cell cancer removed. Another woman had developed facial paralysis after radiation treatment for a carcinoid tumor. One person had suffered facial paralysis from a gunshot wound. A woman had an ameloblastoma (a rare jaw tumor) removed. A man had had facial paralysis for twenty-five years due to a benign facial nerve tumor. And a young man had facial nerve damage caused by a childhood viral illness.

LIST OF PLATES

LOSING FACE, TAKING HEART

by Carolyn Abbate

In *About Face* some of those portrayed, most often the children, are surrounded by family. This can take the form of a single adult hand—a parent, it seems, reaching into the frame with a caress. At other times there are siblings, parents, spouses, other people whose exact relationship to the subject we don't know, but whose connection is written in their faces. That's not meant as a metaphor, a fancy way of saying that the bystanders gaze with empathy and love. Your face is your family. For those who grow up with their biological families, who have been shown the albums of great-grandparents and distaff cousins, or for those who look over their own childhood photographs, the experience of seeing oneself (or one's children) in somebody else can be uncanny. "There," you say, in that particular curved nose from 1893, "there's my son's profile." In my father's particular round cheeks, in the set of his mouth, there too am I.

When your face is deformed by trauma or disease, a new likeness is written into your features. Unlike Sage Sohier's subjects, my face was not paralyzed, and none of her subjects suffered from my specific condition. But what I share with them is that a freak biological lightening strike altered the face I had, and that doctors fixed what could be fixed. Like them, I was treated in Boston, in my case at Massachusetts General Hospital, by master surgeons who are the best in their fields. Before the surgeons intervened, the asymmetries, the swollen immobility and subtle wrongness that observers caught in my face altered the way I was perceived.

I know this to be true by many barometers. Upon reflection, the one that strikes me both as funniest and saddest was fairly trivial. Emerging from almost three years of corrective surgical treatment, I realized that for some time previously, employees at checkout counters, baristas in cafes and the like, had been consistently brusque with me, averting their eyes. Then, suddenly, at the supermarket I was getting friendly chitchat and eye contact—a perceptible uptick in public response. My face has changed, I would silently say to the cashiers, not my soul. Why couldn't you see that soul before? But maybe your soul does improve when your face improves, since facial mobility both reflects and enables positive emotion. And being casually smiled at—which those without monstrosity written into their features can take for granted—gives heart.

Monstrosity is a powerful word, but one that must be confronted with as much fortitude as can be mustered by anyone whose face has gone awry. The disease I had was acromegaly. This condition—caused by a pituitary tumor secreting excess growth hormone—has a colorful place in Hollywood's imagination as "the monster-making disease"; actors afflicted with it routinely played grotesque criminals, misshapen assassins, and a whole host of similar beasts. Before the disease was treatable, the gradual physical deformations were profound and inevitable, and its victims found their places in circuses, as sideshow people.

So you join a new family. Endocrinologists say that they can walk down the street and pick out syndromes by watching faces: Cushing's (puffy moon face), or Grave's (protuberant eyes), or acromegaly (elongated jaw). Like Bell's Palsy, or certain kind of strokes causing drooping asymmetries, acromegaly changes your face in ways that makes you resemble others with the same condition, as the biological lightening strike alters the features of those afflicted homogeneously. Facial bones lengthen; heart shapes becomes thin lozenges, with a vast stretch of jaw below eyes that seem tiny in the new scheme, since they are now, besides being disproportionate, overshadowed by a forehead that has inched forward. The eye sockets drift apart.

All this is not necessarily a symmetric process, and in my case one side of my face grew lower than the other, imparting the El Greco off-centeredness one sees in several portraits in About Face. There are further alterations that come from tissue bulking, and the late stage look—in cases where the illness goes undiagnosed for decades—is thuggish at best. Unlike the changes after a stroke or acute nerve damage, these transformations happen so slowly that the diagnosis is usually made ten or more years after onset. Those around you see a very gradual metamorphosis that perhaps strikes them as oddly unfortunate ageing. The endocrinologist first asks for photographs spanning fifteen years, and, poring over them, explicates every stage in the transformation—the before and the prolonged after. The first hints I had of something other than passing years at work was catching something tiny but disquietingly off-kilter in a new snapshot. It was when a friend who had known me only for five years saw a photograph from ten years before and seemed bothered. It was when my teenage son, looking at a picture of me holding him as a baby, could not see his own younger mother. Who's that with me, he asked.

How could one not have seen? With those photographs laid out on the table it seems so clear in retrospect. Photographic portraiture was critical to a diagnosis. Sage Sohier's photographs, however, are not diagnostic, and show no serial transformations. As she writes, they show, as a singular moment, both an *after*—faces altered from the norm—and a *before*, the faces of her subjects prior to the interventions that would later restore a more normal function and look. And in this singular moment, she discovers a line of beauty.

Anyone who has been robbed of his or her former face will have at best an ambivalent attitude toward mirrors and being photographed. Yet when you make the decision to undergo surgical correction, you undertake a quest—at times terrifying, at times marvelous—where cameras become ubiquitous. If they are not documenting your face on the outside, they are documenting it from the inside, in x-rays and three-dimensional CAT scans. What is moving above all to me about Sohier's photographs is that the subjects have found the equanimity to sit for a portrait, and that at that moment, as they are depicted—whatever their individual narratives may be—they seem interested, calm, curious, alert, thoughtful, mischievous, and at peace. While being any of these things with a damaged face is not so easy, the being at peace seems particularly elusive. Going into the decision to have surgery, it is hard to avoid the error of imagining, hoping, that your face can be returned to what it would have looked like had the disaster never struck. Even when the fixed-up version looks pretty good, it never really looks like your self. The mirror stings every time, and will for the duration.

Before surgery, and in its intermediate stages, there is another mistake that is so easy to make, and less amenable to applications of mere common sense. That is to put your present life aside, entering into a state of perpetual deferral, with some imagined facial restoration fleeing forward on a tailwind that blows it ceaselessly into the future. This state is intransigent: you can rationally believe that things can't be fully mended, and still paradoxically believe that you should wait, and wait, because only by waiting and enduring and looking forward can you reach the prize that is being carried away by the wind. A life thus locked in anticipation remains a life deferred for the duration.

That phrase, "for the duration," is often used by doctors. I first heard it quoted by a friend whose arm was paralyzed and made permanently useless in his late teens. He also told me there is a progression in medical talk as stately, and as predictable, as church fathers processing by rank. First there is encouragement to hope, the roll call of therapies. Then cold water,

saying how and why things didn't work. And, finally, when there is no more to be done (you will remain this way for the duration), the delicate referral to another kind of doctor: the psychiatrist, tasked with assuaging whatever sorrows may now arise. "Yeah," said my friend, "the fancy parade goes by, and you're left with the guy sweeping up the confetti, and he's piling it up in front of you. Asking you how you feel about it."

What "for the duration" means, of course, is until you die. Or, for the rest of your life. But the word "duration" is accomplishing some serious psychological legerdemain. It obfuscates the end point, dying. And it magicks away the distressing borderline of "the rest." As in, there was your real face and real self before the genetic accident, the disease, the smashup, but the rest is what you have now. And then there's a subtle scold inherent in the word. Sit up straight: Because your duration is going to have to be endured. I suspect most patients have little use for such outsider heartiness. For us, the aftermath of these lightning strikes is not inevitably some uplifting playlet about the triumph of the human spirit. But, as difficult as it seems, it is in fact critical that one not to be seduced into tolerating deferral by anticipation of eventual betterment. It is in fact critical to ask yourself to live from this moment on, as you *are* and not as you *were*.

This moral is clear from the most famous contemporary story about facial deformity, told in poet Lucy Grealy's *Autobiography of a Face* (1995), and Ann Patchett's memoir about Grealy, *Truth and Beauty* (2005). In childhood, Grealy lost much of her lower jaw to a tumor (Ewing's sarcoma), then lost more of her face to weakened bones and tissue after radiation therapy, and, in the end, also to the mysterious ways in which a face will shrink and collapse after the trauma represented by thirty-eight corrective surgeries. Greely's memoir ends *in medias res* with the apparently successful finale to her surgical quest. At thirty-one, grafts restore

her jaw line to less anomalous proportions. But the story was not over, and was continued by Patchett. Those transplanted tissues, just like the grafts in the past and those to come, would reabsorb. Grealy's pursuit of facial symmetry reached the limits of what medical science could accomplish. And once nothing more could be done she fell into despair, addressed that despair with alcohol and drugs, and died young.

What emerges from Patchett's observations is frustration that her friend could not ultimately accept her physical strangeness, take flight with her literary gifts, and thus be at peace. Grealy, however, knew that looking freakish is an absolute barrier to ordinary relationships built from ordinary love. And her desire for that fata morgana trumped her vocation as a writer. Rationally, that's a trade not worth making, so the story did not have the expected denouement. So much courage, so many re-boots, so many times when the macabre trial of surgical remaking was overcome, and then it ends with the heroine giving up? But perhaps the trade could not possibly have been avoided. Under the circumstances, could any mortal being have turned around, buckled down, and sat productively at the typewriter for the rest of a long, contented life? If you have had your face put out of whack, Grealy's quixotic chase after a reconstruction doesn't seem all that crazy, or seems less crazy to you than to those people who have not been there. Her insight that a comely face counts for so very much in the wide world, and that its theft by rogue biology is a personal Armageddon, hits uncomfortably close to your own midnight fears.

So much more miraculous, then, is what looks out from the faces in Sohier's portraits: the complex alchemy of resilience and uncanniness. How marvelous to us, those with the faces that went awry, that there is an eye, a sense of artistry that finds such faces transfixing and beautiful.

ACKNOWLEDGMENTS

I am indebted to Doctors Tessa Hadlock and Mack Cheney, who have given me their warm support for this project for many years. They have both been incredibly generous with their time, patient with my limitations, and constant teachers—ever ready to share and explain many subtle aspects of their amazingly complex and demanding work. Their work with the patients featured in these portraits involves the rebuilding of lives and spirits as much as the technical and physical aspects of plastic surgery; in many ways it is more art than science. I would also like to thank the many other individuals who play a vital role in the well-being and healing of patients, and who have helped and befriended me during my time at the facial nerve clinic: Missy Allen, Laura Rykard, Virginia Clancy, Mara Robinson, Jen Baiungo, Marcelles Lambright, Paulette Chesley, Robin Lindsay, Doug Henstrom, and Suzanne Day.

Many thanks are due to those who have provided vital help in bringing this book to press: the No Strings Foundation, for helping to make this book possible; Joe Baio, for his early support of this series; Michael Foley, at Foley Gallery, for believing in my work and exhibiting it; Brandy Savarese, my thoughtful and enthusiastic editor at Columbia College Chicago Press; Carolyn Abbate, for her eloquent, insightful essay;

Kent Rodzwicz, who was painstaking in making the scans and digital files, and tireless in creating many versions of the book dummy; the incomparable Color Services: Marc Elliott, Paula Boswell, Wayne Boches, Jim Ferguson, Jon Doucette, Nicole White, John Liz, Barbara Compton, Adam Katseff, Jerry Miller, Beth Gilbert, Amy Essigmann, Izzy Chafkin, and John Carleton; and David Feingold, who inspired and believed in this project from its inception.

In thanks for their generous help and counsel, I would like to extend special appreciation to Chris Killip, Nick Nixon, Abe Morell and Lisa McElaney, Deborah Hirschland, Fred Lipp, Sandra Klimt, Marni Sandweiss, Willie Russe, and Susan Bell. I would also like to thank Bill Charles, Suzanna Shield, Virginia Beahan, Laura McPhee, Len Jenshel and Diane Cook, Richard Schwartz, Heidi Finn, Lily Brooks, Johanna Warwick, Elaine Sohier Gayler, and Wendy Morgan.

Finally, I am most grateful to those whom I've photographed—many more than pictured here—who entrusted me with their stories and allowed me to make these intimate portraits at a very difficult time in their lives. These photographs could not have been made without their courage and desire to help and inform others.

ABOUT THE PHOTOGRAPHER AND ESSAYIST

Sage Sohier's monograph, *Perfectible Worlds*, was published by Photolucida in 2007. Her other series include "Mother," "Peaceable Kingdom," "At Home with Themselves: Gay and Lesbian Couples," and "Almost Grown." She has been awarded a No Strings Foundation grant, and John Simon Guggenheim and National Endowment for the Arts fellowships. Sohier has exhibited widely, and her work is in the collections of the Museum of Modern Art, New York, the Museum of Fine Arts, Houston, and the San Francisco Museum of Modern Art, among others. She is represented by Foley Gallery in New York.

Carolyn Abbate is Professor of Music at Harvard University. She is the author of *In Search of Opera* (2001) and *Unsung Voices* (1991), and is coauthor of the forthcoming *A History of Opera*. She received a Guggenheim Fellowship in 1995, a National Endowment for the Humanities Fellowships for Independent Study and Research in 1986 and 1994, and was awarded the Dent Medal of the Royal Music Association in 1993.